OLD
COLLEGE
STREET

OLD COLLEGE STREET

The Historic Heart of Rochester, Minnesota

KEN ALLSEN

Charleston London

THE
History
PRESS

Published by The History Press
Charleston, SC 29403
www.historypress.net

Unless otherwise noted, all images are by the author.

First published 2012

Manufactured in the United States

ISBN 978.1.60949.614.2

Library of Congress CIP data applied for.

*This book is dedicated to Harold Crawford,
whose paintings showed me how to preserve buildings,
and to Harvey Ellis,
whose drawings caused me to try.*

Contents

Preface

This book is dedicated to Harold Crawford and Harvey Ellis, both of them talented architects and artists with many similarities in their histories but also some very distinct differences. I knew Harold well and have been heavily influenced by his example in my own modest efforts. I never got to meet Harvey, but his renderings continue to give me a paradigm of sheer draftsmanship to which I can aspire but never fully attain.

Harold Hamilton Crawford was born in the far southwestern corner of Minnesota and spent his childhood years on a farm near Eyota, Minnesota. After graduation from Rochester High School in 1908, Harold studied art and architecture at the University of Illinois and at Harvard University. Between 1909 and 1916, he refined his architectural skills and gained practical experience in architects' offices in both Chicago and Boston. In 1916, he returned to Rochester and established the architecture practice that he would actively pursue for the next half century.[1] In his middle age, he found enough leisure time to resume an interest in painting and produced a large number of watercolors. Many of these featured historic buildings and residences from Rochester. These, with a number of renderings done for his practice, play an important role in preserving our local architectural history. Even with his watercolors, done for his own pleasure and as gifts, Harold was meticulous in researching the buildings he painted and left an accurate representation of them. He continued producing art until his death in 1981 at age ninety-three.

Harvey Ellis was born in Rochester, New York, in 1852. Educated in the public schools of Rochester, he was a talented artist and traveled extensively

Harold Crawford, 1916. *History Center of Olmsted County.*

in his youth to paint and also teach art. A natural ability in drawing and design led him into a career as an architectural draftsman, probably more as an expedient to support himself as an artist than from a deep interest in the field. For a time, he partnered with his brother in an architectural practice in his hometown of Rochester. He then became part of a tightly

Harvey Ellis, 1875. *Northwest Architectural Archives.*

knit brotherhood of nomadic draftsmen who traveled from job to job as their services were required. Harvey soon established himself among his peers as the finest pen-and-ink artist among their number.[2] In the hierarchy of this group, the so-called delineators commanded the most respect (and the highest wages). They produced the presentation drawings for the hiring architect, who used them to obtain commissions from prospective clients. Between 1885 and 1893, Harvey Ellis plied his trade around the country as he moved from office to office. He worked in a number of architectural offices in Minneapolis during this period, notably that of Leroy Buffington. Here, he produced renderings for many of the major residences, businesses and public buildings in the Twin Cities. In 1893, he returned to Rochester, New York, where he concentrated on painting and teaching. In 1903 and 1904, he accepted commissions from Gustav Stickley to produce architectural designs for his *Craftsman Magazine*. Stickley was a leader of the Arts and Crafts movement, producing furniture and related goods in his factories at Syracuse, New York. He soon hired Harvey to produce a number of furniture designs that turned out to be major sellers. Unfortunately, this activity was cut short when Harvey Ellis died in 1904.[3]

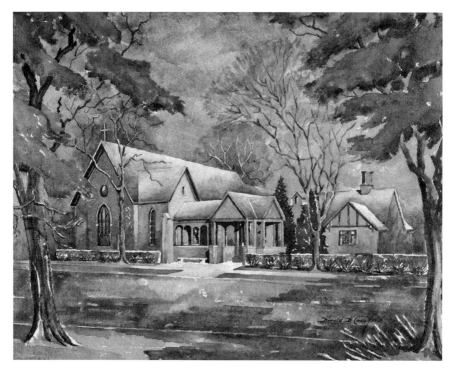

Calvary Episcopal Church, undated watercolor by Harold Crawford. *History Center of Olmsted County.*

When I first met Harold Crawford, I was equally impressed with his art and his gentle humanity. For the last ten years of his life, that admiration grew. After his death, I started drawing some of his houses in pen-and-ink, just as a personal tribute. This led to my association with the History Center of Olmsted County, where I became an unofficial steward of four hundred rolls of drawings by him, cataloging and repairing them. This culminated in my first book, a biography of Harold and a catalogue of his work.

My introduction to Harvey Ellis was less direct. In the 1980s, my wife and I attended a show at the Minneapolis Institute of Art featuring a large group of architectural drawings by Twin Cities architects. A significant number prominently displayed the name of Leroy Buffington, who practiced in Minneapolis between 1874 and 1931. This set of original pen-and-ink renderings drew me closer, and I spent a long time just enjoying them. Then I noticed that they had not been done by Buffington but by a delineator named Harvey Ellis. My interest in Harvey dated from that first contact. Though I had been doing house design and plans for a number of years in pencil, it was

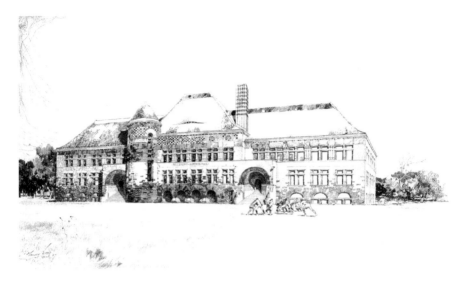

Pillsbury Hall, University of Minnesota, 1887 rendering by Harvey Ellis. *Northwest Architectural Archives*.

that first exposure to Harvey that caused me to dig out my old inking gear and start relearning what I was taught as an apprentice back in the 1950s. It took a while, but in 1995, I created a series of seven renderings of houses designed by Harold Crawford and placed them in a gallery for sale. Much to my surprise, the prints of these first drawings actually sold and influenced me to expand my repertoire to other historic buildings.

My connection with Harold Crawford and the History Center has led me to a number of other activities, among them a series of architectural walking tours of Rochester's historic Pill Hill district. One these tours led up 4th Street Southwest, home of so many early movers and shakers of local history. Known as West College Street until 1918, it assumed its current designation within a new scheme adopted by the city. With only a few exceptions, all of the extant structures along it date from after 1900. By the 1970s, virtually every old building in the five blocks immediately west of Broadway had fallen victim to growth and development. Where vibrant early businesses and elaborate homes stood, parking lots, condominiums and more recent commercial buildings now occupy that space. As I led tours along the street, I tried to recapture the feeling of old College Street and emphasize the earlier structures no longer there. This led to a number of renderings done for the tour brochure to reconstruct just a few of the "lost buildings." To ensure as much accuracy as possible, I used many sources: old photographs

and postcards, insurance and plat maps and old first-person descriptions in early newspapers. On rare occasions, original plans still existed. In some cases, as new evidence surfaced, I would completely redraw a building to ensure its accuracy.

This process of reconstruction, and ultimately a form of building preservation, led to the production of a significant number of renderings.[4] Over the past few years, I started to visualize this book and began to focus on producing drawings that could recapture and preserve the buildings of old College Street. I also began gathering source material on the people who built them and lived or worked in them. My first criterion for inclusion of a building in this book was its importance in the history of the street and of Rochester. The second was the availability of sufficient historical source material to accurately reconstruct the building. There are thirty-three pen-and-ink renderings in this book. The buildings chosen all predate the end of World War I in 1918.[5] All but three are lost buildings that have fallen to development or natural disaster. The exceptions are two survivors dating from before 1900 and the estate of Dr. W.J. Mayo. I have selected William Mayo and another pioneer settler, George Head, to personify the street during two important periods in its development.

I hope you enjoy this, my modest attempt at historic building preservation, as much as I have enjoyed the production of it. Harold and Harvey, I hope you enjoy it too.

Acknowledgements

I have obtained information from a number of sources in order to create this book. Thanks go to the staffs of the Minnesota Historical Society, the Mayo Clinic Archives and the Northwest Architectural Archives at the University of Minnesota for their assistance. The bulk of what went into this book, however, came from one source: the History Center of Olmsted County. Its biographical files and photo collection were completely opened to me during my research. Over the years, I have spent countless happy hours huddled over a table in its library or burrowing in its vault, looking for elusive facts. Its staff have all become personal friends, and I consider the History Center my second home.

Not all of the research I do on Rochester's buildings and their owners ends up in a publication. Much of it is by the request of people who merely want to augment their own genealogical investigations or are simply curious. My good friend Alan Calavano and I do a goodly amount of this type of work on behalf of the History Center. We are constantly sharing our findings with each other whenever our paths cross. Thus, a lot of the interesting little facts that pop up in my writings are thanks to his efforts. It is these little gems of local history that can spice up an otherwise dry narrative. Thank you, Al, for all you do.

Much of what goes into a work such as this one begins with a first-person story shared by someone who knew an individual of interest or shared some story about an old building. I have always absorbed as much of this anecdotal history as I could. Leading walking tours always yields stories told

by attendees about houses and people who lived in them. Homeowners are another rich source. Sometimes a story describes a person who I hadn't heard of and leads to hitherto unknown facts. Of course, not all stories turn out to be true or have been slightly skewed by the passage of time. This is why everything must be verified by careful research. Once in a while, though, you find a person with exceptional knowledge to share. You seek them out and ask them to just tell you stories. Barbie Withers is a favorite source of the inside history of Pill Hill. She grew up there and has spent her entire adult life there. Barbie's cousin, Ben Scott, has been another good source. A fellow member of the Society of Architectural Historians, he and I have made many road trips together as he shared his great stories. Another key contact over the years has been Dr. Paul Belau. His sharing of his own wide knowledge of Pill Hill and its history has aided me many times. My thanks also go to all the many property owners who have so generously hosted my wife and me as we toured their homes and learned about the history of their original owners.

As always, my warmest gratitude goes to my wife, Nancy, my partner in all of these projects. Taking notes in the background while I absorb anecdotal information, she makes sure I always verify the facts before using a story for my own purposes. She is also my first reader on whatever I write and is willing to patiently debate the finer points of English grammar when I go too far afield. Nothing of what I do could be achieved without her quiet and calm support.

PART I

The Evolution of a Street

According to local lore, Rochester was founded by George Head, who arrived by wagon with his father, brother and wife in the spring of 1854. Ownership of all land in the area had been assumed by the federal government,[6] which was selling it to claimants under the preemption laws[7] then in effect. In fact, others arrived and took up land along the river's edge before the Head party arrived. One of the early claims was established by a small group of speculators from Winona and was for 160 acres on the north bank of the Zumbro River,[8] fronting a natural ford and just below a series of rapids. They had laid four hastily cut logs in a rough rectangle to simulate a structure and departed temporarily. Upon his arrival, Head saw the obvious advantages of the site and did some "preemption" of his own. Scattering the logs, he and his family began immediately to erect a permanent log structure. The original claimants returned, and weapons were drawn on both sides. Fortunately, no shots were fired. The original claimants retreated and turned to the safer and surer vehicle of the courts for satisfaction.[9]

On a hot summer day in 1854, George Head yoked his team of oxen to a large log and dragged it in a northerly direction from the riverbank. He was closely followed by his wife, Henrietta, riding a horse. A few other early settlers gathered to watch the fun. According to legend, George then named the newly established path Broadway, along which a new town would surely grow.[10] He named the town Rochester in memory of the city of the same name in New York, where his family first resided after their arrival from England in 1825. The little settlement grew from this seminal event and

would become the county seat of Olmsted County. The city of Rochester was officially surveyed and platted in 1855, but just prior to that event, George Head moved to obtain another prime piece of real estate that had attracted his attention.

In 1854, as George Head and others were fiercely competing for choice sites along the river, a claim was filed on the quarter section abutting Head's original tract on its west side. The original claimant's name is lost,[11] but his intentions for the land he claimed have survived in the name of the rise on its western edge, College Hill. The hill had been well known long before the coming of the white trappers, traders, missionaries and other travelers using a well-worn path to its summit. The path followed an easy ascent, avoiding a steep drop to the north.[12] At its crest, the path forked, one branch continuing westward down the far side of the hill[13] and the other following the ridge to the south.[14] Atop the hill, the original claimant visualized a school, a theological institute and seminary, named for a wealthy benefactor back in the East. Word was sent of the building opportunity to Frederick Huidekoper,[15] a resident of Meadville, Pennsylvania, seeking his financial support. However, he had no interest in investing in a school in an as yet unsettled territory. The claim to the land on which the Huidekoper Institute would have sat lapsed for nonpayment. But the name College Hill had already been adopted by the locals, and it alone would survive.

In early 1856, word spread around the little settlement that the claim had lapsed. Four local men headed for College Hill to stake out their own claim to this prime quarter section. Upon their arrival, they found a much larger party already at work, removing old stakes and replacing them with their own. It was George Head and a group of his friends who had moved even more quickly. The local men voiced their disapproval, accusing Head of violation of the preemption laws[16] and demanding their right to the claim. Heavily outnumbered, the disappointed group was forced to retreat. Later, they brought charges against George Head, who paid a settlement of $3,600 to the original four men. Thus, for a nominal price, Head obtained ownership of a major piece of the newly established town. Later in 1856, the first official plat of Rochester was surveyed, and the area west of Broadway was included under the name Head and McMahon's Addition. Head's partner in the addition, Eleazar McMahon, probably held a very small financial share in the addition but was very instrumental in all of George's many land deals through his legal expertise. What little we know about McMahon is based on the memories of C.C. Willson, another early Rochester attorney.[17] McMahon was a convivial sort, fond of drink and part of Head's inner circle

of friends. According to Willson, when he first arrived in 1855, McMahon was already in practice in Rochester. Eleazar McMahon left for Florida in about 1865 and died there a few years later.

George Head did not name all the streets in the newly platted town, but he did name a few. College Street was pretty much a given since it led to the hill of the same name. The street at the crest of College Hill, following the old path south along the ridge, was dubbed Cutler Street in honor of Head's brother-in-law and major financial backer. On the brow of College Hill, on a full square block, George immediately started to erect a fine house. It overlooked the downtown area and the river from its vantage point. Fronting the house on the east was Genesee Street, named by Head for the river passing through his onetime hometown of Rochester, New York. On the plat, Broadway was chosen as the north–south delineator. Thus, Head's property included all of West College Street. East College Street continued on the other side of Broadway across a bridge spanning the Zumbro River and to Dubuque Street.[18] In 1856, George Head's Inn, its back to the river, looked straight up Broadway to the north, with East College Street to its right and West College Street to its left.

The locale we are concerned with in this story is West College Street, ten blocks in length, from Broadway to the summit of College Hill. Within a short time after the completion of George Head's home, others began populating the new neighborhood with even finer houses. West College Street evolved quickly from a crude footpath into a well-graded gravel thoroughfare. Elms were planted on both sides, and within a few years, they formed a leafy arch. The houses built between 1856 and 1900 may well be called the "pioneer homes" of College Street. Following many different styles popular in the Victorian era, they housed a majority of Rochester's founders. The earliest residents of the street included lawyers, merchants, bankers and manufacturers. The doctors would come later.

Of all these early residents, George Head truly personified the pioneer spirit that built so many towns across the West in the 1800s. His story begins with his birth in England in 1823. He was the son of a merchant ship captain who brought his family to Rochester, New York, when George was only two years old. Educated in the public schools there, he adopted the baker's trade. The entire family moved west in about 1845 and relocated in Watertown, Wisconsin. There, George, his father and his younger brother operated a successful grocery and bakery. George was a restless young man and soon became bored with the lucrative but predictable business of baking. He found an outlet for his excess energy by also serving as a deputy marshal in

George Head, circa 1872. *History Center of Olmsted County.*

Watertown. He soon became known as a fearless keeper of the law. Once, when a gang fled to remote Beaver Island in Lake Michigan after a crime spree in Watertown, George pursued it alone. He captured the ringleaders and returned them to Watertown for trial.

Henrietta Neilson was the daughter of recent immigrants residing in the nearby town of Waukesha. George made her acquaintance while visiting his older sister and her husband, Morris Cutler. George immediately began to pay court, and the couple married in 1849. George was twenty-six, and Henrietta was eighteen. They set up housekeeping in Watertown, but soon George's restless nature began to stir. He convinced his father and brother to sell their business and join him in seeking opportunity in the newly opened lands west across the Mississippi River.[19]

Thus it was that the Heads arrived at the banks of the Zumbro River in the summer of 1854. George moved quickly to acquire large tracts of land

Henrietta Head, circa 1860. *History Center of Olmsted County.*

and used them as a basis for other business interests in the new settlement that would become Rochester. In 1856, when the new house on College Hill was completed, George and Henrietta left their quarters in their inn at the south end of Broadway and moved up the hill. The new house had ample room for more family members, and soon Henrietta's parents and her three sisters arrived. Within one year, two of the sisters married men who had recently arrived and settled in the new town. Dora married Andrew Nelson, and Emma married J. Franklin Van Dooser. Both of these men were soon employed in various business ventures with George as backer and sometime partner. The youngest sister, Sophia, remained single and stayed on with George and Henrietta.

George Head was an aggressive entrepreneur and began starting businesses. Some prospered and some did not. As to his personality, we have only a description written by his brother-in-law, J.F. Van Dooser, many years later.[20] He describes George as being always kind and generous, especially to his friends and members of his extended family. But Van Dooser also remembered George as one who was not a man to be crossed. The little town of Rochester soon hummed with activity, and George Head was in the midst of it. It served as a junction for five stagecoach lines, all of which initially stopped at George's inn at the head of Broadway.[21] In 1857, a dam[22] was erected along the northern stretch of Broadway to form a millpond. To

take advantage of the elevated river, a millrace was dug from the riverbank near Head's Inn, dumping back into the river downstream below the dam. A number of mills[23] grew up along this source of controlled water power.[24] Other businesses followed: a farm implement manufacturer, a furniture factory, two carriage builders and three breweries. Business buildings grew along Broadway, with retail operations on the main floor and offices and residential flats above. With the advent of statehood in 1858, after fierce campaigning against neighboring towns,[25] Rochester became the seat of Olmsted County.

In addition to his business interests, George Head was active in church affairs. Calvary Episcopal Church was built in 1860 on land donated by the Heads. George served on the vestry of his church for a number of years. He was also politically active, serving as First Ward alderman during the Civil War years. George and Henrietta were socially active in the community and surrounded by an extended family of Neilsons, Nelsons, Heads and Van Doosers. George Head was living the life he had come west to find in 1854. All of this was financed by loans from a local bank. The First National Bank was owned by John Cook, another early settler. The majority of George Head's assets were landholdings, and most of these were held by Cook's bank as collateral for loans. In the years immediately following the Civil War, Minnesota was in a boom period. Railroads crisscrossed the new state, hauling wheat to the eastern markets. Land values soared, and George used this to further increase his loans at the bank.

A nationwide financial panic in 1870 caused markets in the East to collapse. The bottom dropped out of the wheat market, and many fortunes in Minnesota suffered as a result. George Head saw the value of his collateral plummet, and when the bank called in his loans, he was forced to declare bankruptcy. By liquidating most of his other holdings and turning over his home to the bank, he discharged his debts.[26] In 1871, George and Henrietta again boarded a wagon bearing a few possessions and headed west. Sophia, Henrietta's younger sister, accompanied them. Their destination was Fergus Falls, Minnesota, on the border with South Dakota. There, George would recoup his fortunes by following the same process of land preemption and development that had worked for him in Rochester. Brother-in-law Morris Cutler still provided the financial backing.[27] Another fine home was built, and the Heads became pillars of another new community. George again became active in local politics and also served as a partner in a bank.

This prosperity was marred by Henrietta Head's death in 1876. Her body was returned to Rochester for burial. In 1879, George married Sophia in

Fergus Falls. Within one year, George's health began to fail. In 1883, on his doctor's recommendation, George and Sophia headed for Bermuda to seek a warmer climate. Only a few days after his arrival, George Head died and was buried on the island. A bereaved Sophia traveled alone back to Fergus Falls. One year later, George's body was recovered and returned to Rochester, where George Head finally found his final resting place beside Henrietta. But the saga continued. The Cutler family[28] back in Wisconsin claimed almost all of the Heads' assets[29] in Fergus Falls. A suit was brought against them on Sophia's behalf and was highly publicized. Attorney Frank B. Kellogg[30] was engaged to represent Sophia, and an out-of-court settlement in her favor soon ensued. Sophia Head died in Fergus Falls in 1889. Her body was also returned to Rochester for burial with her husband and other family members around her.

West College Street continued to evolve after the Civil War into the prime residential area of the ever-growing city around it. By 1883, many fine homes existed around George Head's original house on the hillside, still vacant and owned by John Cook of the First National Bank. On a hot summer day that year, disaster struck the town without warning. A massive tornado swept over the crest of College Hill and traveled down West College Street. It then veered to the northeast and cut a swath of death and destruction across Rochester. Damage to the properties along West College Street was significant, but repairs were soon made. The exception was George Head's house, which had its roof totally ripped off, exposing the structure below. The house was never repaired, and eventually, very little of it remained.[31]

In the midst of the Civil War, a national draft was established to fill the ranks of the Union army. The War Department in Washington assigned an adjutant general to each state to administer the draft system. He then assigned a team to each congressional district, including an examining surgeon, to register all males between eighteen and forty years of age. Rochester was the center of population for the First District. Thus it was that a country doctor relocated there to serve as examining surgeon. Dr. William Worral Mayo was born in England but had been an American citizen for a number of years. He and his wife, Louise, had followed the western migration to Minnesota and moved around the state. They eventually ended up in the town of Le Seur. When W.W. Mayo moved his wife and children to Rochester, the couple finally put down permanent roots. William W. Mayo established himself as a physician and surgeon, soon well known for his successful operations. Surgery was usually done in a patient's home in those days, often on a kitchen table by the light of kerosene lamps. In most

cases, the only surgical assistant available was the patient's spouse. As the years passed, Dr. Mayo would often be accompanied by his two young sons, Will and Charlie. They soon became adept at assisting their father. W.W. Mayo prospered in his practice and also became involved in local politics. He built a home in the center of Rochester[32] and also acquired a farm on the outskirts of town,[33] where his children spent their summers doing chores. Charlie loved the outdoors and established a pattern he would pursue as a gentleman farmer through a long and illustrious medical career. Will was of the opposite opinion and soon found work in a downtown pharmacy, helping with prescriptions in order to avoid farm work in the summer.

Both brothers would complete their medical education and return to Rochester to join their father in his practice. Dr. William James Mayo received his MD at the University of Michigan in 1883. Younger brother Charles Horace Mayo received an MD from Northwestern University in 1888. Young Dr. Will returned to Rochester just a few weeks before the tornado of 1883 struck. He and his brother joined their father and other doctors in dealing with the many injuries left in the storm's aftermath. All able-bodied members of the community rallied to assist in the town's recovery. An unlikely set of volunteer nurses was a group of Franciscan Sisters, trained as teachers, who operated a small parochial school and convent. Rochester had no hospital at the time, so the injured were treated in whatever space could be found in those buildings still standing. The intensive work brought Dr. W.W. Mayo into close contact with Sister Mary Alfred, Mother Superior of the convent. A friendship grew between them based on mutual respect.

When the after effects of the tornado were finally overcome and the rebuilding of the town was well underway, Sister Mary Alfred approached her friend Dr. W.W. Mayo with a proposal. Rochester needed a hospital. The sisters would build it if Dr. Mayo would staff it. Hospitals of the day had a bad reputation, thought of as places where the indigent went to die. Dr. Mayo was skeptical about the project, but the determined sisters proceeded to raise the funds, primarily through their own frugality. Construction of St. Marys Hospital began in 1887, and the first patients were received in October 1889. The three Mayos were soon performing operations in the new surgical suite. Under the newly accepted techniques of antiseptic surgery, infection was greatly reduced, and the two younger doctors began to amass an impressive series of successful operations. Word gradually spread through the eastern medical establishment. Soon, the galleries above the operating tables at St. Marys were crowded with visiting doctors. Most came to observe and learn, but a few came to stay. The Mayos were soon part of a

group surgical practice, which would eventually add diagnosis and research to its mission. By the early 1900s, this grew into the Mayo Clinic,[34] which today ranks among the most elite medical centers of the world.

Located just south of a growing cluster of medical buildings in the center of Rochester, old West College Street started to undergo a period of change in the late 1800s. The homes of the pioneers still occupied large tracts of land along the upper reaches of the street on College Hill, and a few more still abutted the industrial and retail areas near Broadway, on smaller lots. The arrival of new staff for the burgeoning group practice of the Mayos triggered a major building boom in the sleepy little town on the banks of the Zumbro River. Many of the original houses on College Hill were torn down as owners of the properties subdivided entire blocks into standard-sized lots. Other original pioneer structures at the foot of West College Street also fell to the expanding downtown commercial area. After 1900, development of fine homes on the southern slopes of College Hill accelerated as more doctors moved into the area. Soon, the hill had a new nickname coined by the locals: Pill Hill. In 1918,

the palatial home of C.C. Willson at the very summit of the hill burned down. It was the last of the pioneer houses on West College Street. Now there were only a handful of structures on the entire street dating from the nineteenth century. The ruins of the very first pioneer home, George Head's house, still occupied the only undeveloped full block of land on West College Street.

Dr. William James Mayo, co-founder of the Mayo Clinic. *History Center of Olmsted County.*

Dr. Charles Horace Mayo, co-founder of the Mayo Clinic. *History Center of Olmsted County*.

This second wave of development was triggered by the needs of newly arrived physicians who wanted suitable housing for their families. This development along West College Street and neighboring Pill Hill closely paralleled the early growth of the Mayo Clinic. As George Head personified the pioneer residents of the street, Dr. William James Mayo would be his modern successor. As the Mayo Clinic evolved from a regional surgical service into a nationally known center for research and diagnosis, it was "Dr. Will" who guided it. He and his younger brother, "Dr. Charlie," would shape the organization through the early years of the twentieth century, following Dr. Will's vision of what it could become. The two brothers built adjacent homes along West College Street in the late 1800s. In 1910, Dr. Charlie left for his newly built country house, Mayowood, southwest of town. Dr. Will remained on West College Street, though he sought more space to expand his own residence.

The last full block of undeveloped land on the street was the former site of George Head's house on the brow of Pill Hill. The land had been obtained

by the late banker John Cook in the bankruptcy proceedings of 1870. It was now owned by his son, also named John Cook, who resided in Chicago. In 1914, at the urging of her husband, Hattie Mayo boarded a train for Chicago, where she sought out Mr. Cook. He quickly agreed to sell her the entire block, and she was on the next train back to Rochester, her mission accomplished. By 1918, all traces of George Head's home had vanished and were replaced by the house and other buildings of the William J. Mayo Estate. The stately house on the hill signaled a new era for the old gravel street, which followed the original footpath up to the summit. Now it was paved with brick and lit by streetlights at night. Modern residences lined the street, their well-groomed lawns bordering newly installed sidewalks. And if anyone should forget what had caused all of this prosperity, St. Marys Hospital underwent its own remarkable development and growth on the western slopes of the hill.

It was probably just coincidence that the local post office caused a major overhaul of street names in Rochester that same year of 1918. But it ended up being emblematic of a major shift in the nature of the street itself. The old street names on the original plat of 1856 vanished, except for Broadway. They were replaced with numbered streets crossed by numbered avenues, designated by quadrant. West College Street became 4th Street SW. Genesee Street, a memorial to George Head's vision of what the Zumbro River's water power could become, was named 7th Avenue SW. Even Head's late brother-in-law lost his own local claim to fame when Cutler Street became 10th Avenue SW.

Old College Street, now renamed, continued to develop as a reflection of the ever-growing nearby Mayo Clinic campus. Between the two world wars and immediately after, it continued to be an enclave made up primarily of medical professionals. To the south, Pill Hill also filled up with fine homes, many designed by local architects, especially Harold Crawford. The Ellerbe firm of Minneapolis also contributed the designs for many of these residences[35] in addition to its primary mission as key architect for all Mayo Clinic buildings. By 1950, the Pill Hill area had become fully developed, and those seeking quality houses had them built elsewhere. Two popular areas were the Belmont Slopes Subdivision[36] and the Merrihills Addition.[37]

By the early 1970s, 4th Street SW had undergone a complete transformation in just a few short years. The old paving bricks were replaced by asphalt. In the first five blocks of the street west of Broadway, the old houses began to fall to other projects. A new Christ United Methodist Church occupied a full block. Two large condominiums, Five Oaks and High Point, were built

along the street. Much of the remaining frontage became parking lots for the Mayo Clinic's many employees. Beginning with the 600 block, the rest of the neighborhood maintained its character and does so to the present. A great loss to the appearance of the street was the removal of the great old trees along its borders, due to the spread of Dutch elm disease in the 1980s. In 1990, the upper part of the street, from 7th Avenue SW to 10th Avenue SW, was included in the Pill Hill Historic District. The nomination package[38] placed 114 different structures on the National Register of Historic Places. The entire area represents a major part of Rochester's architectural and personal history.

PART II

The Buildings of Old College Street

The examples included in this section do not constitute all of the known nineteenth-century buildings along West College Street. But they, as well as their owners, form a historical cross section of that thoroughfare and its role in the development of the city around it. Today's 4th Street SW is a busy artery, leading from Broadway on its east end to its terminus ten blocks to the west atop College Hill. The large complex of St. Marys Hospital sprawls on the western slope of the hill, and a connecting entrance road from Fourth Street attracts a great deal of traffic. Frequent cars pass on the street in both directions, their drivers preoccupied and oblivious to the ghosts of old houses and businesses along their route. The reader is encouraged to shut out the image of the current street and try to visualize West College Street as it was more than a century ago. Imagine it as a quiet gravel road with large shade trees along its edges. Cars do not exist, nor do the noisy helicopters landing and taking off from the nearby hospital. At the lower end of the street, some early retail stores are mixed with manufacturing operations, but after passing these and moving up the hill, the loudest sounds are those of horses' hooves and buggy wheels crunching in the gravel. Imagine large houses reflecting various styles of the day, populated by people who molded our city into what it is today. Try not to think of them as flat images in stiff old photographs. They lived in these houses and worked hard in these businesses, their children's voices ringing as they played along the old street.

No attempt is made here to arrange things in chronological order but, rather, to simulate a leisurely stroll up old West College Street. We begin

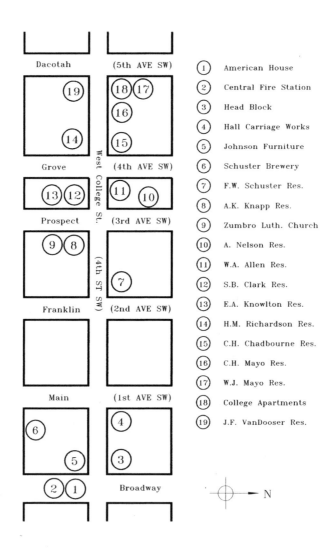

Lower West College Street, with keys matching the figure numbers in the text.

at the lower or eastern end of the street where it intersects with South Broadway and then follow it to its end atop College Hill. To fully explore the neighborhood, we turn briefly down the cross streets as necessary. The addresses given reflect the old street names in use before 1918. An appendix at the end of this book provides a cross reference with current streets and avenues. Additional appendices define architectural terms used in the building descriptions and provide brief descriptions of builders and designers. The focus is on buildings built and destroyed before 1918, but in a few cases, the original building was replaced by an equally interesting structure that itself has fallen. These, too, are included here in order to preserve their history. In three cases, extant pre-1918 buildings are also documented for reasons that will be stated in their accompanying text.

THE SOUTH END OF BROADWAY

When George Head arrived in the area in 1854, the first thing he did was to lay claim to a quarter section of land on the north bank of the Zumbro River. Situated by a natural ford and just above a series of rapids, the location afforded major opportunities for development. Head's first project was to erect a two-story log building to house his family members and to serve as Rochester's first inn and tavern. The Heads operated the inn themselves and hired another person, Robert McReady,[39] to run the tavern portion of the business. Early accounts sometimes refer to Head's Inn and McReady's Tavern as though they were on separate pieces of land. In actuality, they occupied the same structure and were both owned by George Head. McReady has the dubious distinction of importing the first barrel of whiskey into Rochester in 1854, after he assumed management of the tavern. During the winter of 1854–55, the amount of spirits in the barrel remained miraculously level, thanks to infusions of water from the nearby river. McReady's predawn trips to the Zumbro's bank only became apparent to his customers in the early spring of 1855, when the barrel's contents froze solid on a very cold night. It is assumed that McReady refreshed his whiskey supply with the unadulterated version as soon as the trail opened to Dubuque that year.

George and Henrietta Head operated their thriving inn in the midst of a rapidly retreating frontier in 1854. Most new arrivals in the little settlement availed themselves of the inn's accommodations and its associated tavern. George, a convivial sort, was soon surrounded by a large coterie of faithful

friends, some transient and others who came to stay. That first winter was a rugged one. Wolves were heard howling at night along the riverbank. Small bands of Native Americans still arrived on the inn's doorstep asking for food. One hungry group even entered the kitchen and made off with a large leg of mutton. The only law in Rochester that first winter was a group of self-appointed "regulators," who moved quickly to suppress the most overt cases of crime among the recent arrivals. When Olmsted County was officially chartered by the Territorial Legislature in 1855, the settlement received its complement of newly appointed government officials, including a county sheriff.[40] The regulators[41] then resumed their usual roles in the community. On July 4 of that year, Rochester celebrated the first of many Independence Days. The celebration centered on McReady's taproom at Head's Inn. In the evening, a fireworks display was performed by the only resident who owned a revolver and could fire many shots in succession. The sobriety of the celebrants was not an issue, but fortunately, no injuries were reported.

By 1856, George and his wife, Henrietta, were ready to move into their new home on College Hill. The inn was sold to Asa LeSeur. He enclosed the log structure in a frame shell and initially named it the York State House in honor of his home state, New York. It was soon renamed the American House and bore this name for the rest of its existence. The building (Figure 1) was not particularly interesting architecturally. Purely functional, it reflected a rough pioneer practicality long after that initial period of settlement had passed. On its highly visible site at the south end of Broadway, it was a constant reminder to the local citizens of where they had originated but was not necessarily consistent with how they wanted the city to evolve.

In late 1854, a stagecoach line was established between St. Paul and Dubuque, Iowa. Following a rough trail,[42] it passed through a number of small villages, including Rochester. Because of other east- and westbound stage routes that soon passed through it, Rochester became an important transfer point. Initially all stages stopped at Head's Inn and its successor, the American House. Newer, more comfortable accommodations were soon offered by better hotels. The main stage stop moved to the Bradley House, just a block to the east. The American House soon became nothing more than a boardinghouse. Catering to local workers seeking decent lodgings and simple meals, it survived for many years.

In the late 1880s, the City of Rochester purchased the American House and the land along the riverbank at its rear. The old inn was razed, and in 1890, a new central fire station (Figure 2) replaced it on the site. The building was of red brick, an ornate example of late Victorian style. Its

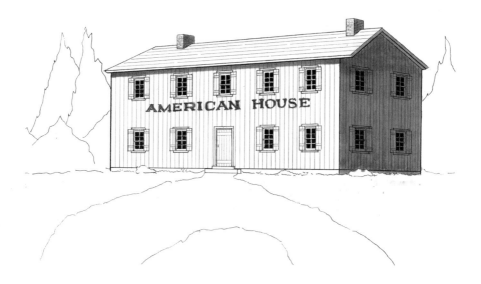

FIGURE 1: The American House, at the head of Broadway. Its wood siding disguised George Head's original log inn built in 1854.

façade was totally symmetrical. The centered entrance fronted the stair hall to the upper stories, plus the obligatory brass pole. Recessed pairs of doors opened into two large bays housing the equipment, initially horse drawn and later motorized. The second floor provided quarters for the resident firefighters. Above the bays, a pair of cantilevered balconies jutted out, each highlighted by a decorative wrought-iron arch, painted white.[43] The façade of the first two stories was accented by four prominent pilasters, rising to a decorative cornice and topped by small accents.

The third-floor attic featured dormers over the outer bays, with a tower soaring upward in the center. The open interior of the tower served as a drying area for wet canvas hoses. The tower was eighty-five feet in height and was topped by a quadripartite curved copper roof. It featured a clock[44] with faces on four sides. Each face was six feet in diameter, and the clock was visible in all directions. The hours were struck on a large bell. For the forty years of its existence, this building served as an important landmark, as it dominated the view when looking south down Broadway. It was a far cry from the rather shabby American House that preceded it. It announced to the world that Rochester was a prosperous and progressive city that had turned its back on its rough pioneer past and now looked only ahead.

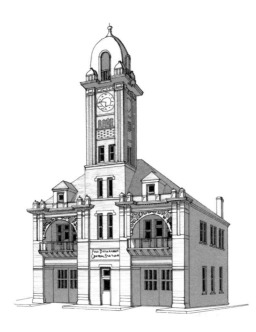

FIGURE 2: Central fire station,
a landmark at the head of
Broadway for four decades.

The area in front of the building contained a tall flagstaff, nicknamed the Liberty Pole. It was a key feature and served as a meeting place for local residents. All local parades and processions began here. When a prominent citizen died, it was customary for all businesses on Broadway to close as the funeral cortege formed up in front of the fire station and made its way to the burial. Other events also occurred around the foot of the Liberty Pole. During World War I, a great influenza epidemic caused a local moratorium on public gatherings in Rochester. But on November 11, 1918, Armistice Day, the moratorium was ignored as a wild and spontaneous celebration erupted near the old flagpole. Motor vehicles, cheered on by spectators, raced up and down the nearby streets and caused a tragic death.[45] In the aftermath the next morning, the revelers soberly resumed the moratorium.

On the grassy plot between the fire station and the river, a busy farmers' market existed. The city built and maintained two large open-sided sheds to shelter the vendors' horses. Another building associated with the market area was a small two-story structure to the east of the fire station.[46] It was Rochester's first public restroom, providing a place for farmers' wives to nurse and diaper babies and to escape the heat and dust of the market. In 1930, the South Broadway Bridge[47] was built, and the old firehouse was replaced by its more modern counterpart just to the west. The market area became the right of way for South Broadway, which now extended across the river.

The Women's Building was replaced by today's Riverside Building in about 1918. The site of so much of Rochester's early history thus disappeared under a layer of concrete and has been forgotten by many.

HEAD'S BLOCK, 5 WEST COLLEGE STREET

George Head's first commercial enterprise in Rochester was located in a building (Figure 3) on the northwest corner of Broadway and West College Street. It was built in 1856 and was the first large general store in the city. A large advertisement of 1859[48] shows Head as proprietor and the heading "Head Quarters—Still Ahead and No Falling to the Rear." The advertisement lists a large assortment of clothing, groceries and other items for sale. It goes on to state that, in addition to cash, all kinds of grain or other produce would be accepted as payment. This same advertising copy was used without modification for a number of years, but with the proprietor's name soon changed to "R. Neilson."[49] The building was of red brick with multiple entrances and sported elaborate trim on the first-floor façade. In addition to its obvious commercial purpose, Head used it to set the tone for the subsequent buildings that would follow it along Broadway prior to the Civil War. When George Head underwent bankruptcy in 1870 and lost the

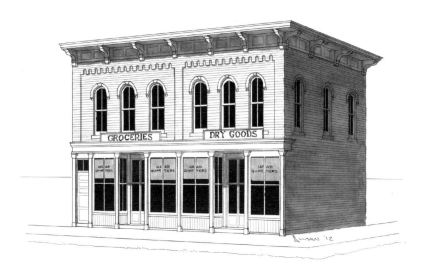

FIGURE 3: Head's Block, George Head's first commercial venture in Rochester.

vast majority of his Rochester holdings, he managed to keep this building. He would return from Fergus Falls periodically to maintain the property[50] until the time of his death. The building by that time housed the hardware store operated by George's brother-in-law, J.F. Van Dooser. When Head died in 1883, the property passed into other hands.

In 1899, a two-story addition was built in the vacant lot just to the west. The updated building continued to house various retail businesses on the main floor. The addition housed a cigar factory until 1914. That year, the two buildings were combined with 327 South Broadway, which abutted them on the north. This became the Rommell Hotel. The original building and the addition along 4th Street SW survived until the early 1950s. They were then razed and replaced by the parking area there today.

T.P. HALL CARRIAGE WORKS, 23–25 MAIN STREET

Thomas P. Hall was born in London, Ontario, in 1847. A carriage maker by trade, he arrived about 1876 in Rochester, where he built his factory and showroom (Figure 4). It was located on the northeast corner of West College and Main Streets. The rest of the block along Main Street was already occupied by J.P. Spencer's farm implement business. The men were partners, with the two businesses complementing each other. Hall's Carriage Works advertised a full line of "fine carriages, phaetons, buggies, carts, wagons and

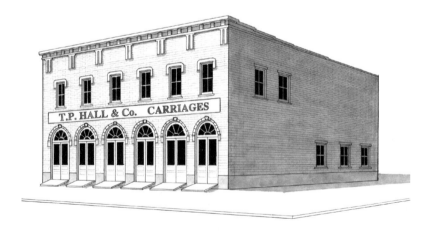

FIGURE 4: Hall's Carriage Works.

sleighs." He also offered repainting and repair services. In addition to his business interests, Thomas Hall was also politically active. He served a term as Second Ward alderman in 1896–98 and was the city treasurer for many years. He died in Albuquerque, New Mexico, in 1940.

The building had its manufacturing and repair operations on the first floor. The brick façade was pierced by large doors that accessed the working bays inside. Offices shared with Spencer occupied the second floor. The building lost its roof in the 1883 tornado but was soon repaired. By 1917, the carriage manufacturing business was fading rapidly with the advent of the automobile. Spencer and Hall maintained their prosperous farm implement operation on Main Street but moved their offices to 412 South Broadway. The carriage factory building was sold and soon razed. Ironically, the next occupant on that corner would be Rochester's very first gas station.

P.F. Johnson Furniture & Undertaking, 401–5 South Broadway

When this building was first erected in 1879, P.F. Johnson established a mortuary there (Figure 5). As was common in the nineteenth century, undertakers also doubled as furniture dealers. Buying up used furniture from estates and repairing it in the casket shop for resale was a lucrative sideline to the funeral business. P.F. Johnson & Company operated until 1900, when he partnered with Richard L. Tollefson. After Johnson died in 1908, the business was known as R.L. Tollefson Furniture & Undertaking. In 1914, the furniture business was split off and moved to a separate location farther north on Broadway. Embalmer and longtime employee Earl Vine was made a partner in the mortuary business. Tollefson & Vine continued operations on the site until Tollefson's death, and it then became E.A. Vine & Sons.

In about 1950, the Vine Funeral Home moved to a new location, and the old building at the corner of Broadway and 4th Street SW ended more than seventy years in the undertaking business. A long succession of other businesses has occupied the building since then. The same is true of the smaller casket shop building abutting the main building on its south side. In the 1960s, the main building was named the Labor Temple and housed the offices of a number of local trade unions. A bar, the Union Club, occupied a portion of the main floor. This became the Broadway Café, which served its hearty fare until the building was purchased for a proposed theater and performing arts center.

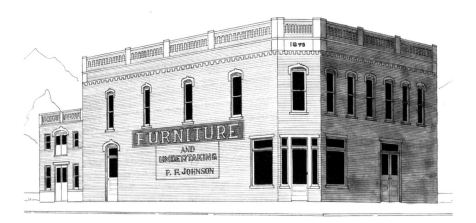

FIGURE 5: Johnson Furniture & Undertaking.

When the building was first erected in 1879, the southwest corner of Broadway and West College Street was a prime location. At the end of Broadway, near the American House, the building was a magnet for farmers and their wives from the market area on the nearby riverbank shopping for furniture. After 1890, when the new fire station replaced the old boardinghouse, the area became even more of a hub for downtown Rochester. In 1930, the South Broadway Bridge was constructed just south of the old funeral home. As the center of commercial activity steadily moved north on Broadway in the 1930s and 1940s, the old building was eclipsed and became less attractive to tenants. In its earlier years, it had received a number of modifications. A major remodel of the exterior was designed by architects Frederick Mann and Harold Crawford[51] in 1916. The uniquely angled main entrance was modernized, and larger plate-glass windows were installed on the main floor along Broadway and West College Streets. A more recent remodel has covered the old red brick with pinkish-gray stucco. The original arched hoods over the second-floor windows still attest to the building's roots. The year of its birth, 1879, still appears prominently above its entrance.[52]

SCHUSTER BREWERY, 400–500 MAIN STREET

Henry Schuster arrived in Rochester in 1862 from Milwaukee, Wisconsin. He began plying his trade as a blacksmith in a small shop on Broadway. By

FIGURE 6A: Schuster Brewery as it looked prior to the fire of 1871.

1865, he had accumulated sufficient capital to enter the brewing business. By that year, Rochester had three breweries. Schuster acquired one of these,[53] the Union Brewery, located on a site near the river south of West College Street. He renamed it the Schuster Brewery. An access road[54] into the property divided the brew house on the south and a smaller house to the north (Figure 6a). For the first few years of operation, this small house would serve as the residence of the Schuster family. In later years, it would house the resident brew master.

Henry Schuster made a number of improvements to the brew house, including a major modification to the basement adding a large, arched vault capable of storing 1,200 barrels of beer. The business prospered, and in 1870, Schuster was able to pay off his backers and become the sole proprietor of the brewery. In 1871, a fire began in the furnace room of the wooden brew house and destroyed it completely. A new and far grander structure soon arose from the ashes (Figure 6b). Red brick was chosen as the material for a large three-story brew house with a four-story tower graced with a cupola and flagpole. To ensure against further fires, the boilers and furnaces were housed in a separate building on the east side. In addition to the brewing vats, the brew house included spaces for receiving and drying malt, a bar room and the company's offices. The little house across the driveway was eventually absorbed into a larger bottling plant, with a wing added for retail sales. A large warehouse and keg storage building was erected just behind the bottling plant.

FIGURE 6B: Schuster Brewery, circa 1910.

Henry Schuster died at the peak of his career in 1885. The brewery management was assumed by his two eldest sons, Henry Jr. and Frederick. They had learned all aspects of the business from their father. The brothers divided the duties. Henry Jr. handled the sales, accounting and other office tasks, and Fred ran the manufacturing side. He had been sent to Milwaukee as young man to work in the Frank Valk Brewery there and to learn the brewer's art. He would later further his education at the American Brewing Academy in Chicago. It was there that he created a beverage that would change the Schuster Brewery forever. Schuster's Malt and Hop Tonic contained only a trace of alcohol and was intended as a dietary supplement. It gained a great regional popularity when the sisters at St. Marys Hospital started recommending it to patients recovering from surgery. By 1900, a network of independent representatives was marketing the tonic nationwide. The gross revenues of the Schuster Brewery in the first two decades of the twentieth century averaged about $1 million annually, the vast majority of which was from the tonic. Its beer, though tasty, sold only locally.

The Volstead Act and the ratification of the Eighteenth Amendment to the Constitution initiated the "great experiment" of Prohibition after World War I. Breweries and distilleries around the nation began to close down, and Schuster Brewery followed suit on January 1, 1922. The Schuster brothers had enjoyed a long period of prosperity and invested their profits carefully, primarily in real estate. Fred and Henry turned their backs on the brewing

business and founded the Schuster Realty Company, with offices in the old brew house. The rest of the buildings remained vacant until 1925, when they were rented by the Rochester Dairy. In 1927, Henry died, and Fred continued to operate the realty business. The brewery property was purchased by the Rochester Dairy Cooperative in 1941, and Fred moved his offices to another location. He died in 1945 at the age of eighty-one. When the cooperative moved to a new facility on the opposite side of Broadway in 1958, the old brewery finally fell to the wrecking ball. Its tall tower had dominated the south end of downtown Rochester for more than eight decades. Today, the city of Rochester's major industry consists of two major players: the Mayo Clinic and IBM Corporation. But long before these, there was another large enterprise that, in its day, overshadowed all others and is now fading into memory.

F.W. Schuster Residence, 205 West College Street

Frederick Schuster purchased the lot on the northwest corner of West College and Franklin Streets in 1905, just a short walk from his brewery. By 1907, an older building on the lot was razed and replaced by a new home (Figure 7) for the Schuster family. The residence was an eclectic mixture of

Figure 7: Frederick Schuster residence.

styles, with both Craftsman and Tudor features. The lower story was of dark red brick, with a deep porch along the front and east sides. The second-floor exterior was buff-colored stucco, with a large bay window over the porch. On the attic level, two dormers extended from the hipped roof, both with half-timbering. The larger dormer was supported by decorative brackets. All sash in the façade were of the three-over-one style, a key Craftsman feature of the time.

After Fred Schuster died in 1945, his widow resided in the house until the mid-1950s. The house was then used as a church for a few years and was finally razed in about 1960.

A.K. Knapp Residence/Zumbro Lutheran Church, 222 West College Street

Abel K. Knapp arrived in Olmsted County in 1857 from Vermont. He took up land north of Rochester, a full section near the village of Potsdam. He rode the crest of the wheat farming boom but wisely diversified his operation prior to the great collapse of 1870, when wheat prices plummeted and ruined so many of his neighbors. Switching to high-quality livestock, he acquired even more land. He introduced the Holstein breed to the county and built a large dairy herd, becoming one of the wealthiest farmers in the area. When Knapp retired from farming in about 1887, he decided to move into Rochester. He purchased a large lot and erected a home on it (Figure 8), where he resided until his death in 1899. With the exception of some simple trim along its cornice, the house was extremely plain and functional. It evokes the practicality of those late nineteenth-century Foursquare-style houses that still anchor so many farmsteads across southern Minnesota.

Abel Knapp's widow resided in the house until 1911, when she also died. The house was then purchased by R.L. Smith. He sold it to the congregation of Zumbro Lutheran Church in 1926. The old house was replaced in 1927 by a new red brick church building (Figure 9) in the Gothic Revival style. A large education building was added in 1953 just to the south of the church. In 1969, Zumbro Lutheran moved to a new facility on the corner of 6th Street and 4th Avenue SW and sold the old property to the congregation of First Baptist Church, which had recently sold its own landmark downtown church building. The new congregation utilized the church and education building until it, too, moved into new

Figure 8: Abel Knapp residence.

Figure 9: Zumbro Lutheran Church.

quarters in 1980. The entire property was then purchased by the Mayo Clinic, and the church was razed. Today, the frontage along 4th Street SW is a Mayo employees' parking lot, and the education building has been remodeled to serve as part of the clinic's facilities.

A. Nelson Residence, 315 Prospect Street

Andrew Nelson was born in Norway in 1837. He came to the United States in 1854 and settled first in Wisconsin. By 1859, he was in Rochester, working for George Head in his store on West College Street. That same year, he married Dora Neilson, Henrietta Head's sister. In 1860, they built a house along the west side of Prospect Street, just north of West College Street. Andrew left Head's employ in 1862 and opened his own business. By 1869, he was operating in his own newly built Palace Block.[55] Here, he initially sold clothing and home furnishings but later specialized in carpets and draperies. He was an active member of the Democratic Party and highly involved in politics at a local level. He was elected mayor in 1887. During his term, he oversaw a number of progressive projects as Rochester got its first gas works and a municipal water system. The expense of laying mains and other infrastructure caused critics of his "radical policies" to rail against him, but he prevailed.

The Nelson house (Figure 10) was an example of the Stick style, a simplified alternative to Victorian excess. The brackets at the bottom edges of the gables and the porch are complemented by the equally simple trim at the gable ends. The clapboard siding with its horizontal and vertical members reflects and articulates the inner structure. This "stickwork" is what gives the style its name. Andrew Nelson died in 1901. His obituary described him as warm and generous but also very direct in manner. This no-nonsense personality was directly reflected in the style of his house. It was razed in 1916, shortly after his widow moved across the street to her daughter's house, where she died in 1918.

Andrew's wife, Dora, was obviously a family-oriented woman. When Oakwood Cemetery first opened in the 1860s, the Nelsons purchased a burial plot for their own eventual use. Dora also bought an additional large plot in her own name for use as a resting place for members of her extended family. Here are the graves of her two sisters, Henrietta and Sophia, with that of their husband, George Head. Dora's parents and Head's father are also buried in the plot, plus three of Dora's children who died in infancy. Unmarked by

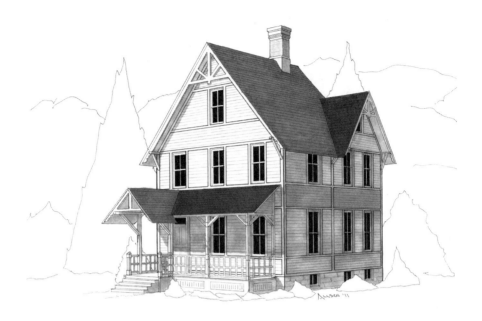

FIGURE 10: Andrew Nelson residence.

stones, these graves were finally given a large central monument, erected many years later by Andrew and Dora's daughter, Nora Nelson Rowley.

W.A. ALLEN RESIDENCE, 305 WEST COLLEGE STREET

Dr. Wilson Adolphus Allen was born in Pendleton, Indiana, in 1834. After graduation from Franklin College, he entered into the pharmacy business and also taught mathematics at the Pendleton Seminary. He served an apprenticeship with a local doctor and began practicing medicine. Ill health soon forced him to seek a healthier and more robust life. In 1856, in true pioneer fashion, he and his wife, Flora, took up land near Cedar Rapids, Iowa, where he began farming. After three years of this, with Wilson's vigor restored, the couple returned to Indiana, but his physical condition deteriorated again. When the Civil War broke out in 1861, Dr. Allen volunteered but was rejected due to his poor health. He was at that time six feet tall but weighed only slightly over one hundred pounds. No one would have guessed that such a poor physical specimen would live to become a centenarian.

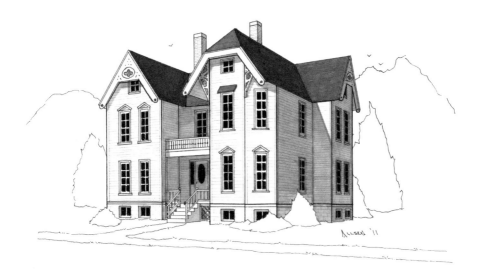

FIGURE 11: Dr. Wilson Allen residence.

In 1866, the couple left Indiana for good. Seeking a better climate, they again moved west, this time to Plainview, Minnesota. Many returning Civil War veterans brought back infectious diseases such as smallpox and typhoid fever. During small outbreaks in Plainview and nearby villages, Dr. Allen's compassionate treatment and common-sense approach[56] soon endeared him to his patients. His tall, lean figure, his gentle manner and his neatly trimmed Van Dyke beard were the very epitome of the classic country doctor. In 1870, he left his practice in Plainview and attended the Hahnerman Medical College in Chicago for two years. He received a degree in homeopathic medicine and a certificate allowing him to provisionally practice. He received his full certification in 1879. In 1872, the newly educated Dr. Allen and his family moved to Rochester. He rented office space on Broadway and started a medical practice that would stretch into the 1930s. He particularly attracted rural families, some of whom he treated for multiple generations. Dr. W.W. Mayo was a popular local surgeon with an active practice of his own and a notable number of successful operations to his credit. But he would often consult with Dr. Allen and defer to his superior diagnostic skills.[57] Allen continued his busy practice for many years and was going strong at 96, still seeing patients in his office. He was also still driving his own car on house calls around Rochester and elsewhere in the area. A few years later, with his own health finally failing, he died in 1934 shortly after his 100th birthday.

When the Allens first moved to Rochester in 1872, they purchased a residence on Dubuque Street.[58] Wilson and Flora moved to a new home (Figure 11) on West College Street in 1880. The house was erected on a high basement and was an eclectic mixture of styles. A high front porch was sheltered by another porch on the second story. It was flanked by two wings thrusting toward the street. The eastern wing was deeper than the one to the west. In addition to verge boards on the gable ends, the eastern wing had angled corners with a jerkinhead roof and large sawn wood brackets under its eaves. All windows were of the two-over-two style, some of which had Palladian-style triangular hoods.

The Allens moved back to their original property on Dubuque Street in about 1910 and sold this house to J.T. Lawler. In 1950, it became a rooming house called the Maples. It continued to house visiting clinic patents and their families until it was torn down in the early 1970s.

S.B. Clark Residence/E.A. Knowlton Residence, 306 West College Street

S.B. Clark arrived in Olmsted County in 1857 and originally settled in Oronoco. After his marriage in 1858, he and his new bride relocated to Rochester. He established himself as a blacksmith and mechanic, installing and maintaining machinery in the new Olds & Fishback Mill. In about 1870, the couple purchased a lot on the southwest corner of West College and Prospect Streets. Here they built a modest home.[59] Clark continued to prosper, eventually becoming a major stockholder in more than one early Rochester mill. He was also a tinkerer and inventor. In 1885, he patented his design for a device to separate butter from raw milk. He shortly thereafter became president of the newly formed Rochester Butter Separator Company. To reflect their new financial success, the Clarks commissioned a major remodel of their house in about 1888.

The expanded Clark residence (Figure 12) reflected late Victorian taste and blended well with its neighbors along lower West College Street. It was an eclectic design,[60] with Italianate details predominating. The bracketed wide eaves with peaked breaks in the roofline were typical of that style. Also typical were the two elaborate porches with arched woodwork and decorative balustrades. A wrought-iron widow's walk atop the roof was a prominent feature.

In 1909, the Clark house was purchased by Mr. and Mrs. E.A. Knowlton. Eliot Ainsworth Knowlton was born in Vermont in 1844. In 1867, he arrived in Rochester and obtained a clerk's position in the store of J.D.

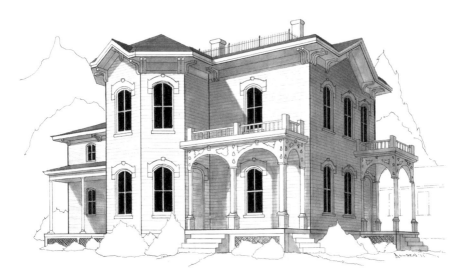

FIGURE 12: S.B. Clark residence.

Blake, founded in 1861 in partnership with Alfred Leet. Blake's sister, Ella, married Eliot in 1873. When Blake moved to Minneapolis in 1882, the store continued as Leet & Knowlton.[61] Leet retired in 1897. Knowlton's sons were brought into the business, and it was henceforth known as E.A. Knowlton & Company. It became Rochester's premier department store. The old store building burned in 1917. Knowlton commissioned architect Franklin Ellerbe to design the replacement,[62] which opened in 1918 on the northwest corner of Broadway and Zumbro Street (now 2nd Street SW). In addition to his success as a merchant, Knowlton founded the Union Bank of Rochester in 1891 and served as its president for many years. E.A. Knowlton was a strong personality and the very model of a self-made man.

A few years after his purchase of the S.B. Clark house, Eliot and Ella decided to tear it down and replace it with something more modern. The architectural firm of Purcell & Elmslie[63] was then one of the most fashionable in the state of Minnesota, still known today for its design of a whole series of acclaimed Prairie-style homes in the Twin Cities area. According to William Purcell, E.A. Knowlton appeared one day at the firm's offices in Minneapolis with a rough set of floor plans drawn on wrapping paper from his store. He gruffly demanded that Purcell "build it just like this." A quick glance by Purcell told him that it would be impossible to follow the new client's orders. No provision had been made for stairways between floors, for example. Knowlton remained adamant that his plan be followed exactly. As the tension built, Purcell probably

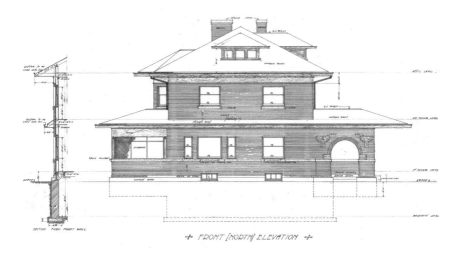

FIGURE 13A: Eliot Knowlton residence, as originally designed by Purcell & Elmslie. *Northwest Architectural Archives.*

was tempted to just walk away from the commission.[64] Instead, he turned the project over to a newly hired designer, Marion Alice Parker.[65] She worked patiently with Knowlton and finally produced a design in 1911 that reflected the progressive style so associated with Purcell & Elmslie (Figure 13a). The plan featured a very horizontal appearance and had a pair of George Elmslie's trademark terra cotta details flanking the main entrance. Had the house been built to the plans, it would have joined that select group of Purcell & Elmslie residences that are so revered today by architects and architectural historians. But that was not to happen.[66]

When E.A. Knowlton returned home with his completed set of plans, he had the old Clark house razed and began construction of his new home, this one facing on West College Street. He hired a local builder who faithfully followed Ms. Parker's floor plan and construction details, completing the house in 1912. But Knowlton insisted on tinkering with the exterior appearance. A number of the window openings were moved and reconfigured. The roof, originally specified as unobtrusive brown shingles, became deep green tiles. The pale yellow Roman brick exterior was as designed, but Elmslie's terra cotta details were eliminated and a timber porte-cochere was added over the driveway. The site, originally planned to be open and airy, was enclosed in a heavy wooden fence, with an ornate lych gate prominently featured (Figure 13b). The result was still attractive, however, and the house remained a landmark on 4th Street SW for many years.

FIGURE 13B: Eliot Knowlton residence, as it was finally built.

Ella Knowlton died in 1925, followed by Eliot in 1927. The house remained vacant for four years until the estate was settled in 1931. Eliot's oldest son, George, became the owner. Prior to taking up residence, he hired architect Harold Crawford to make some modifications to the house. When they were finished in July of that year, and the night before George's family was to move in, he died of a heart attack. His widow, Madge Knowlton, then occupied the house with her three children and remained there until 1952. That year, the house was sold, and she moved to California, where she died in 1975.

The new owners were the Jewish congregation of Rochester. They operated the building as a synagogue and community center until they moved to new quarters on 2nd Street SW in 1978. The new owners announced their plans for the property, which included demolition of the building. Local preservationists[67] attempted to save it, but to no avail. The old house was razed and is now a parking lot for Mayo Clinic employees.

H.M. RICHARDSON RESIDENCE,
406 WEST COLLEGE STREET

Henry M. Richardson was born in Orange County, Vermont, in 1844. In 1862, at age eighteen, he enlisted in the Fifteenth Vermont Infantry and

served in a number of engagements during the Civil War. His regiment was near the First Minnesota at the Battle of Gettysburg,[68] and he would have seen their gallantry firsthand on the banks of Plum Creek. Perhaps Henry was influenced by this when, after the war in 1869, he chose Minnesota as a destination. That year, he settled in Haverhill Township near Rochester and established a successful farming operation. He continued to expand his holdings, and his farms prospered accordingly. In 1881, he won election as sheriff of Olmsted County and moved into Rochester. He served in that position for ten years.

In 1891, Richardson stepped down as sheriff and ran for the Minnesota state legislature. In 1892, he began his first term as a state representative. In addition to his farm incomes, he also invested in a major grocery and produce market called Richardson & Younglove, located on Broadway. At about the same time, he founded the Fiber Flax Mill[69] and served as its president. From 1882 to 1892, Henry and his family resided in the sheriff's quarters near the jail on Zumbro Street. In 1892, he acquired a lot on the southwest corner of West College and Grove Streets. Here he built a new home.

The house (Figure 14) was three stories in height, with an attic above. On the first floor, a deep porch extended across the front and along

FIGURE 14: Henry Richardson residence.

both sides. The main entrance faced West College Street, and a smaller entrance led from a kitchen wing toward Grove Street. The porch's heavy cornice was topped by a balustrade. The second story, like the first, was sided in clapboards. Large bays overlooked the streets on two sides. The second story was topped by a cornice with a decorative railing. Inset slightly behind this railing, the third story nestled under two large gables. Large windows were recessed in heavy arches, and the gable ends were clad in shingles. The attic gable was set back from the floor below. Situated on a slightly elevated lot, this tall house must have appeared to soar above its neighbors.

Henry Richardson lived well in his house[70] and continued to prosper until his death in 1912. His widow remained in the house until 1921, when it passed into other hands. Divided into large flats, it had a number of residents over the ensuing years. In its later years, it also housed the offices of Lutheran Social Services. When Christ United Methodist Church was built in 1958, all the other houses in the block were razed to make room for it. The big house on the east end of the block was the sole survivor and lasted until 2002, when the church finally replaced it with a parking lot.

C.H. CHADBOURNE RESIDENCE,
407 WEST COLLEGE STREET

Charles H. Chadbourne arrived in Rochester in 1862 and established a store selling books and stationery. Many merchants in early frontier towns also doubled as moneylenders, and Chadbourne began to serve that function. As a result, he became one of Rochester's first bankers. After a few years of combining his retail and lending businesses, he sold his store and focused solely on banking. After weathering the great financial collapse of 1870, Chadbourne officially incorporated as Rochester National Bank in 1876. He served as its president until 1887. He then sold his interest in the bank to competitor John Cook, who absorbed it into his own First National Bank. Chadbourne then moved to Minneapolis.

In about 1868, Charles and Henryetta Chadbourne purchased a large lot on the northwest corner of West College and Grove Streets. The new house (Figure 15) that immediately followed was an exuberant example of the Italianate style. It reflected the Chadbournes' new prosperity

FIGURE 15: Charles Chadbourne residence.

and standing in the little community. It sat well back from the street, surrounded by a wrought-iron fence. It had entrances on both of its street frontages, connected by a continuous porch topped with a balustrade. The main façade faced south, overlooking West College Street. It featured a gabled wing with a main-floor bay window, also topped by a balustrade. The second-floor window above the bay was sheltered beneath a small decorative awning roof. This feature was repeated on the east and west sides of the house. On the west side of the bay was a two-story wing with its own porch. The windows of the house had arched hoods. This and the heavy brackets under a wide eave were typical of the style. However, the builder opted not to crown the house with the tower so typical of the Italianate style[71] and instead added a widow's walk with its own balustrade matching those below.

When Charles Chadbourne departed Rochester in 1887, the house was sold to P.G. Heintz,[72] who lived there for a number of years. The home then passed through the hands of a number of early Mayo physicians. It became a rooming house in about 1930, operated by Mrs. Reka Fender. During World War II, the building was divided into flats and became the Hillside Apartments; it was finally torn down in the early 1960s.

C.H. MAYO RESIDENCE, 419 WEST COLLEGE STREET

Edith Graham was the first nurse-anesthetist to work with the Mayo brothers and their early partners. The sister of Dr. Christopher Graham, she soon attracted the attention of young Dr. Charlie Mayo. A courtship ensued, and the couple was married in April 1893. The lot next door to his brother's home was available, and a new house was completed there in 1894. Following Will and Hattie's advice, the architect who had designed their house was also commissioned to do the same for Charlie and Edith. This was the firm of C.G. Maybury & Son of Winona, Minnesota. The result was a large Queen Anne–style home (Figure 16), which became known as the Red House. The main floor of the house sat high above the lot on a raised basement. The façade was dominated by a turreted tower flanking a second-floor porch overlooking the street below. Other Queen Anne trim features gave the house a lofty appearance, eased somewhat by its warm red exterior. The elaborate carriage house at the rear of the property was shared by both brothers.

The brothers would always ride to work together on those days when they were both in town. The closeness of their relationship also resulted in a planned pedestrian tunnel between the two houses, vetoed by both wives. They agreed that the two brothers needed a little time apart to devote to

FIGURE 16: Dr. Charles Mayo residence.

family activities. A compromise was reached by installing a buried voice tube, similar to those used on ships at that time. In the morning, the brothers would signal their readiness to leave for work via the tube and then meet at the carriage house.

Charlie and Edith moved to their new country home, Mayowood, in 1910. The Red House was turned over to the YWCA and served as its headquarters for many years. The house then became a nurses' residence and was renamed Edith Mayo Hall. It spent its final years as a privately owned rooming house for clinic visitors.[73] In 1987, the old house fell to the wrecker's ball[74] and soon became yet another Mayo Clinic parking lot.

W.J. Mayo Residence/College Apartments, 427 West College Street

Dr. Will Mayo married Hattie Damon[75] in 1884, after he returned from his medical training and entered practice with his father. The young couple moved into his parents' home and lived there until 1887, when their first daughter, Carrie, was born. They began to need more space and bought the property on the northeast corner of West College and Dakota Streets. They had the old house on the lot torn down but carefully preserved the many large trees growing around it. Their new home was completed in 1888 (Figure 17). A second daughter, Phoebe, was born during the Mayos' residence here. Built in the Queen Anne style, its driveway was sheltered by a porte-cochere. The house was encompassed by a broad porch with a gazebo at the corner. Many modern conveniences, such as gaslights and running water,[76] were included, and the house included three large fireplaces. A carriage house occupied the rear of the lot. Unlike the red exterior favored by his brother next door, Dr. Will's house was painted a pale yellow with trim features picked out in white, giving it an understated appearance.

When his brother moved to Mayowood, Dr. Will decided to build a larger home farther up College Hill. His family moved into their new home there in 1918. Their previous residence was replaced that same year by the College Apartments (Figure 18), Rochester's first "luxury rentals." Designed by the firm of Ellerbe & Associates, it was a state-of-the-art structure for the time. The main part of the building facing West College Street was four stories high, rising above a raised basement that also contained apartments. Two wings led to the rear of the property, providing an air space between them. All apartments thus had at

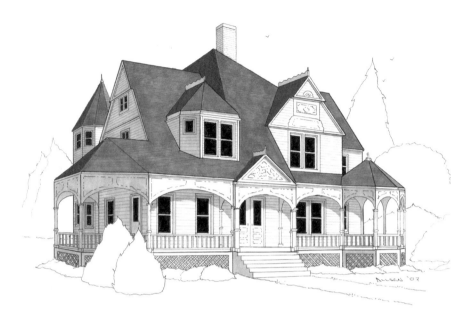

FIGURE 17: Dr. William Mayo residence.

FIGURE 18: College Apartments.

least one exterior wall with windows for light and ventilation. The exterior was a combination of red brick and timbered stucco, which gave the building a Tudor appearance. A small and unobtrusive main entrance led to a central stair hall. Each apartment contained one or two bedrooms, and all had electricity, central heating and individual bathrooms.

The proximity of the apartments to the downtown clinic buildings and to St. Marys Hospital presented an attractive alternative to homeownership for many newly arrived physicians. The large building was soon fully rented, with a waiting list for future vacancies. It continued in its role as a residential hub for nine decades, though it was eventually eclipsed by later modern apartment houses and luxury condominiums along the same street. In November 2007, the old building was razed and replaced with a parking lot. With its demise, a last reminder of old College Street, for which it was named, was lost forever.

J.F. Van Dooser Residence, 428 West College Street

J. Franklin Van Dooser was born in Ohio in 1834 and was raised in Randolph, New York. He came to Rochester in 1858 and soon found a position as a clerk in George Head's store. In 1859, like his good friend Andrew Nelson, he married one of Henrietta Head's sisters. Franklin and Emma Van Dooser initially resided in George Head's roomy house but soon moved to rented quarters elsewhere. Van Dooser served on the first vestry for Calvary Episcopal Church and was present at its consecration by Bishop Henry Whipple in 1860. When the Civil War broke out in 1861, Franklin volunteered and was commissioned a first lieutenant, commanding a company of the Minnesota Mounted Rangers. His cavalry unit saw action as part of Brackett's brigade in a number of western campaigns, including the Dakota Uprising of 1862. Upon his return from service in 1866, Franklin partnered briefly with a Mr. Williams in farm implement sales but soon sold out his interest. He then established a successful hardware business. In the early 1870s, he moved this business into the store building owned by his brother-in-law, George Head. In 1885, Van Dooser sold his Rochester holdings and moved to Ashland, Wisconsin, where he engaged in the real estate business until his death in 1921. He and his wife are buried in Oakwood Cemetery in Rochester.

In about 1868, Van Dooser purchased a large lot from George Head on the southeast corner of West College and Dacotah Streets. Franklin and

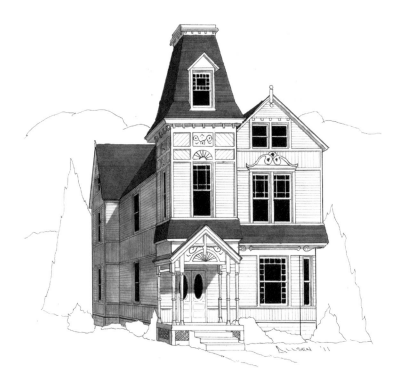

FIGURE 19: J. Franklin Van Dooser residence.

Emma moved into their new home (Figure 19) in the same year. The house was three stories in height, with an eclectic mix of Victorian features. The exterior displayed a series of vertical and horizontal trim members typical of the Stick style. The areas enclosed were of clapboard, made more interesting by varying the direction of the siding. The French Second Empire style was also represented in the three-story tower above the main entrance and also by the mansard roof along the façade between the first and second stories. The appearance of the house was further embellished by a number of sawn wood decorations. The Van Doosers were vey active socially, and the house saw a great deal of entertaining. Frequent dancing parties are mentioned in the local press. These were facilitated by a large wooden dance floor[77] erected on the lawn when occasion required.

After the Van Doosers left for Wisconsin in 1885, the house had a number of owners. In 1950, it was purchased by the Kahler School of Nursing and named Richards Hall. It served as a residence for nursing students until it was razed in 1958 to make room for Christ United Methodist Church.

The Buildings of Old College Street

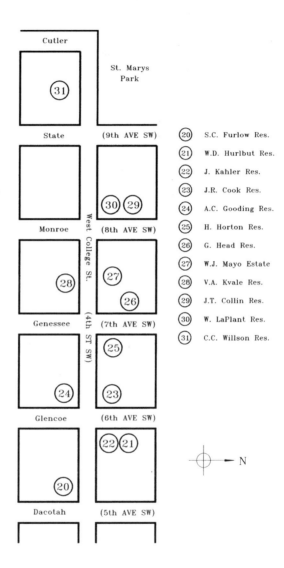

Upper West College Street, with keys matching the figure numbers in the text.

S.C. FURLOW RESIDENCE,
506 WEST COLLEGE STREET

Samuel C. Furlow was born in Philadelphia in 1852 and came to Rochester with his parents when he was a young boy. He was educated in Rochester public schools. A few years later, in 1876, he joined C.F. Massey's department store as a clerk. By 1890, he was a partner, serving as vice-president of the firm. Furlow was active in civic affairs, serving on the Library Board, the Board of Education and the board of Oakwood Cemetery.[78] Samuel Furlow died in 1911. His wife, Elizabeth, remained in their home on the southwest corner of West College and Dacotah Streets. She died in 1929.

The Furlow house (Figure 20) was built in about 1890. It was a large white two-story structure with clapboard siding. The first floor had a bay window on the east side and another on the front, tucked under the porch roof. The porch ran along the entire façade and had a flat roof supported by wooden columns with Ionic capitals. On the second floor, a wide bay window with transom lights was centered above the porch. Wide eaves supported a hipped roof with dormers on all four sides. The lot immediately to the west was also owned by the Furlows. Elizabeth Furlow transformed it into a beautiful formal garden, admired by passersby for many years.

FIGURE 20: Samuel Furlow residence.

In 1926, in order to give their mother additional income, her sons decided to replace the formal gardens with an apartment house. Architect Harold Crawford designed the attractive Furlow Apartments building, which still exists today at 512 4th Street SW. After Elizabeth's death in 1929, the big white home on the corner was divided into flats and served as an apartment house until razed in 2010. It was replaced by the Hamilton Apartments.

W.D. Hurlbut Residence/J.H. Kahler Residence, 527 West College Street

Walter D. Hurlbut was born in Ohio in 1846 and accompanied his parents to Rochester in 1858. After completing his education locally, he immediately joined John Cook's new First National Bank as an errand boy. His rise in the bank was phenomenal. Named assistant teller in 1865 and cashier in 1874, he was elected vice-president in 1895 and served in that role until his retirement in 1899. He died in 1905.

When Hurlbut married in 1873, he already owned a large lot on the northeast corner of West College and Glencoe Streets. A new home (Figure 21) was built on the land. Walter and Ella Hurlbut occupied their new house that year. The house was of a simplified Italianate style. The design was probably influenced by the home of Walter's friend and fellow banker Charles Chadbourne, one block to the east. It had the same hipped roof with a broken pediment, supported by broad, bracketed eaves. Also similar were the arched window hoods. The house had three porches with unadorned doors. The other elaborate trim features of the Chadbourne house were omitted in Hurlbut's home. With its front facing Glencoe Street, it was an efficient two-story structure of red brick, with a major wing thrusting toward the street. The house reflected Walter's conservatism in business and life. Its dignity was further enhanced by the elaborate wrought-iron fence surrounding it.

The house was purchased in 1909 from the Hurlbut estate. The new owner was J.H. Kahler. John Henry Kahler was born in Canada in 1863, but he moved to Michigan as a small child. He completed his education there and took up the harness-making trade, but young John had broader horizons in mind. At age twenty-two, he embarked on an extensive ramble through Europe and South America. By the time he returned, his family had relocated to Northfield, Minnesota, and he rejoined them there.[79] He set out to learn the hotel business. After terms of employment at the Archer House in Northfield and other area hotels, he came to Rochester in 1896, seeking further opportunities. The Cook

FIGURE 21: Walter Hurlbut residence.

FIGURE 22: John Kahler residence.

House was then Rochester's best lodging, but its reputation was beginning to slip due to inefficient management. Kahler was hired, and under his management, the hotel soon turned around and became the finest in the region. This was the same period when prominent physicians from elsewhere were beginning to arrive in Rochester to observe the Mayo brothers' surgical techniques. With a loan from his father, John Kahler soon purchased the hotel from the Cook family. The hotel's fine restaurant and Kahler's focus on service attracted these discerning guests, and the Cook House's reputation quickly spread. By the time Kahler purchased the Hurlbut house, he was already well along in his establishment of a local empire consisting of hotels and retail businesses. Also, in 1909, he built the Colonial Hospital[80] in downtown Rochester and cemented a lifelong friendship with William J. Mayo and an alliance with the Mayo Clinic. John Kahler died in 1931.

In 1923, John Kahler commissioned the architectural firm of Ellerbe & Associates[81] to remodel the old 1873 house. The result (Figure 22) presented a more modern look while preserving much of the character of the original structure. Two major wings were added, with modern windows, and the old red brick was covered by cream-colored stucco. The orientation was shifted to have the main entrance facing West College Street, accessed by a horseshoe-shaped driveway. A new formal entrance on what was formerly the side of the house was created to overlook the driveway and welcome guests to the Kahlers' home.

John Kahler's widow, Mabel, resided in the house until her death in 1958. The house was then occupied for a time by their daughter, Mary, and her husband, Dr. Philip Hench.[82] He died in 1965. In 1973, Mary Kahler Hench donated the property to the Mayo Foundation. It is now a parking lot for Mayo Clinic employees.[83]

J.R. Cook Residence, 312 Glencoe Street

One of Rochester's most successful early business leaders arrived in 1856. John Ramsey Cook opened a small shop and began selling an assortment of goods to the early settlers. Eventually, it would grow into one of the largest mercantile operations in the region. In those early days, the banking industry had not yet arrived in the dusty little settlement, but there was a need for it. Many of those first pioneers had dreams—some of businesses in the new town, some wanting to start farms and others desiring new homes. What

John R. Cook, pioneer
entrepreneur and banker.
History Center of Olmsted County.

they all had in common was the need for cash to realize their visions. In the absence of banks, only merchants had excess cash on hand to invest. Thus, the more successful ones turned to money lending as a profitable sideline. John Cook was particularly adept at spotting good opportunities versus spurious ones, and he soon became prosperous. Eventually, he decided to devote himself full time to financial dealings and turned over management of his mercantile interests to others. In 1864, he founded the First National Bank in a tiny downtown building. In 1869, he built a fine hotel on the southwest corner of Broadway and Zumbro Street and soon moved the bank's offices to larger quarters on that building's first floor.

By 1870, John Cook's bank was holding a large portion of early Rochester's assets as collateral for loans. Much of this was in the form of land originally claimed during the preemption period of the 1850s. Land speculators, George Head in particular, were heavily leveraged financially against their landholdings. In 1870, a financial panic swept the country. Land prices plummeted, and collateral values at the bank dropped accordingly. Loans were called, and a number of land-based fortunes were lost. The panic lasted only a short time. When it ended and land prices returned to normal levels, John Cook owned a great deal of the bank's previous collateral outright. John Cook died in 1880, and his son and namesake, John R. Cook Jr., took over the reins of his father's

business interests. He would later move to Chicago, but the First National Bank continued to be a major factor in Rochester's growth and development.

In 1860, John Cook and his family moved into a new home on the northwest corner of West College and Glencoe Streets. The house (Figure 23) was of red brick and eclectic in style. A wide porch faced Glencoe Street. On it, Doric columns supported a simple cornice with dentils. A double entrance door gave access from the porch. All windows had arched hoods, and a wide wooden cornice with inset rectangles supported the low, hipped roof. The large addition to the north, probably built about 1870, lacked even this small amount of detail. It had simple stone lintels over its windows and omitted the cornice altogether. The house reflected the austerity of its owner. It occupied a full block of frontage along Glencoe Street and was named Five Oaks by its owner in honor of the venerable trees surrounding it.

John Cook's widow died shortly after he did. His son occupied the house for a few years, but by 1900, it was vacant. It would remain so for two decades. In 1918, it was purchased and remodeled by M.C. Lawler. He resided in it for many years, as did his son, Fabian Lawler. In 1960, the Lawler family sold the house to a group of funeral directors. It became the Hillside Funeral Home. It was razed in 1972[84] and is now the site of Five Oaks Condominiums.

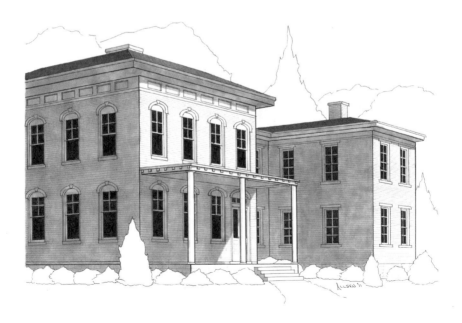

FIGURE 23: John Cook residence.

A.C. Gooding Residence, 411 Glencoe Street

Arthur C. Gooding was born in Rochester in 1871 and completed high school at the old Central School. In 1888, at the age of seventeen, he began his banking career as a messenger boy at the Union Bank. His starting monthly salary was ten dollars. He rose through the ranks at Union Bank and became its cashier. In 1908, he moved to First National Bank. He served as its president until retiring in 1936. A.C. Gooding maintained several other business interests in Rochester, including the ownership and management of the Brown and Arthur Hotels. Gooding kept a business office on the second floor of the C.F. Massey Building, where he worked regularly until the age of ninety-seven. He was also active in civic affairs and was elected to the Minnesota legislature, serving as a state senator from 1918 to 1922. One of his major projects in the legislature was the creation of Whitewater State Park in Winona County. In 1895, Arthur Gooding married Frances Day Faitoute. She died in 1954.

West College Street prior to World War I was a true "bankers' row." The homes of John Cook, Charles Chadbourne, Walter Hurlbut and Eliot Knowlton were joined in 1901 by that of Arthur Gooding. The house (Figure 24) was

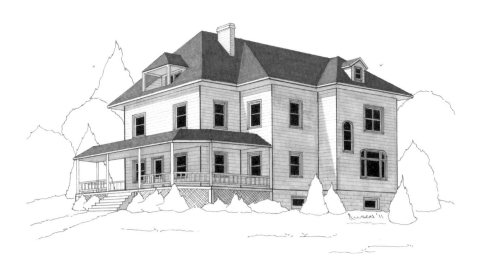

Figure 24: Arthur Gooding residence.

on the southwest corner of West College and Glencoe Streets, directly across from that of John Cook. A large, rambling structure sided in white clapboards, it faced Glencoe Street. The lower story was shaded from the morning sun by a deep porch. An interesting feature at the attic level was a large reverse dormer, shaded by its own deep roof. Gooding was a talented woodworker and, in his retirement, expanded his home workshop to devote himself to his hobby of building fine furniture. His tools and machinery occupied the attic of the house instead of the basement. This was to avoid any dampness, which could affect the wood used in his elaborate furniture creations.

Arthur Gooding died in 1971 at the age of one hundred. He was one of the last links to Rochester's earliest days.[85] In 1978, his home was purchased by developers and razed, to be replaced by High Point Condominiums. At the estate sale, local Pill Hill neighbors gathered to buy up many of the beautiful furniture pieces created by Gooding, and they still occupy places of honor in homes in the area.

H.F. HORTON RESIDENCE, 627 WEST COLLEGE STREET

Horace Ebenezer Horton was born in the small western New York village of Norway in 1843. In 1856, as a boy of thirteen, he came to Rochester with his parents. After obtaining what education was then available here, he was sent back to New York for two more years of schooling. With a strong background in mathematics, he read extensively on building and engineering. A few years after his return to Rochester, he was serving as both Rochester city engineer and Olmsted County surveyor. At the same time, he began his own construction business. The firm's specialty was bridges. The first of these was built in 1867, a wooden span in Oronoco. Horton soon made the transition to steel and constructed six more bridges in Olmsted County between 1874 and 1898.[86] But Horton's business was not limited to Olmsted County. His firm built bridges, major and minor, all across Minnesota and neighboring states. They included a total of seven major bridges spanning the upper Mississippi River.

Horace Horton's talents were not limited to bridge building. His interests expanded into the field of architecture as he designed and built a number of residences and public buildings. When the Olmsted County Courthouse was heavily damaged by the great tornado of 1883, Horton designed the

renovations, including a new tower. By 1889, Horton had greatly expanded his bridge construction business by buying out a number of his competitors. He then formed the Chicago Bridge & Iron Company. He left Rochester and moved to Chicago to serve as president of the new firm. A major aspect of the company's business transcended bridge construction. Its engineers developed an economical design for an elevated water tower in 1894. Soon these were sprouting up above small communities all over the midwestern and western states. Many remain and are still providing service after more than a century. Horace Horton remained at the helm of Chicago Bridge & Iron until his death in 1912.

When Horace Horton married in 1880, he purchased the lot on the northeast corner of West College and Genesee Streets. He designed and built a home (Figure 25) on the property. The house exhibited many of the fashionable trim elements of the late Victorian period but also reflected a restrained approach in its design. A broad porch spread across the façade. It was supported by heavy brackets instead of posts, which gave it an airier appearance. A formal entrance was sheltered under a pillared extension to

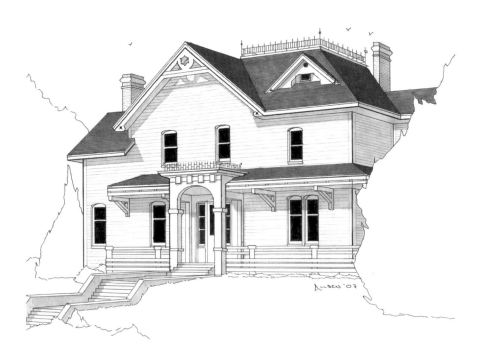

FIGURE 25: Horace Horton residence.

the porch, with a low iron balustrade. On the upper level, a large gable was trimmed with verge boards. These were repeated in a smaller recessed roof dormer. Chimneys with decorative brickwork flanked an iron widow's walk on the roof. All window openings were slightly arched but did not have the usual heavy hoods. The windows were of a modern double-hung style. Overall, the design was a balanced mixture of late Victorian features and some elements later found in Craftsman designs. When the Hortons left for Chicago in 1889, the house was purchased and occupied by the Bamber family. In 1942, it was razed to provide parking space for the Mayo Foundation House, across the street to the west.

G. Head Residence, 315 Genesee Street

Shortly after he acquired all the land along the newly platted West College Street in 1856, George Head began to build a home on the brow of College Hill. He selected a prime site, a full square block. It was on the north side of West College Street, bounded by Genesee Street on the east and by Monroe Street on the west. The house was located on the cross street, oriented to look out over the new town. By the end of 1856, the new whitewashed brick structure (Figure 26) was a prominent landmark on College Hill, noticed by all who traveled on Broadway below. One eyewitness, in a newspaper interview[87] done well after the fact, recalled his arrival in Rochester in late 1856. He and his wife, aboard their covered wagon, gazed with wonder at the fine brick house on the hill above them. He describes the house as "being in the best eastern style." In the 1850s, that would probably have implied the Greek Revival style.[88] When George and Henrietta moved into the house in 1856, it soon became a hub for their large extended family. Henrietta's parents and three sisters soon arrived from Waukesha and took up residence. George's father, John Head, also resided in the house until his death in 1862. The only member of the family who did not live with George and Henrietta on College Hill was younger brother Jonathon Head. He resided on his farm[89] northeast of Rochester. When George's sister, Nancy Baker,[90] arrived in 1858, she and her husband moved in with Jonathon.

When George Head was forced into bankruptcy in 1870, the house on College Hill became the property of John Cook, president of First National Bank. Its furnishings were all removed and sold, and the house remained vacant for the rest of its existence. Far less valuable to the bank

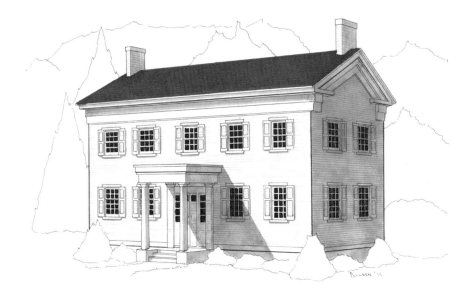

FIGURE 26: George Head residence.

than the land it occupied, it was allowed to deteriorate until the tornado of 1883 administered the final coup de grâce. The roof was blown off and the interior completely exposed to the elements. As West College Street continued to evolve into an exclusive residential neighborhood after 1900, the old Head property on College Hill remained vacant. When Will and Hattie Mayo purchased the block in 1914, all that remained of the old house was a crumbling foundation.[91] All traces of that disappeared as the Mayos began the building project that would become their new home in 1918.

W.J. MAYO ESTATE, 701 WEST COLLEGE STREET

Dr. Will Mayo hired architect Franklin Ellerbe in 1915 to plan a large house and three outbuildings to occupy his newly purchased land on College Hill. His specific requests to his architect were few. Costs were to be kept at a rational level, though Mrs. Mayo was to get whatever she desired in the new house. Dr. Will's own personal specifications included fireproof construction and also some provision for his hobby of astronomy.[92] Hattie Mayo was an

Hattie Damon Mayo, wife of Dr. W.J. Mayo. *History Center of Olmsted County*.

active participant in the design process. An artist from her earliest years, her skills in drawing and an active interest in architecture were honed by her time at the Niles Academy[93] before her marriage. As the drawings for the house evolved in 1915 and 1916, the Ellerbe architects found her input invaluable. She probably influenced the design with her own sketches.[94]

FIGURE 27A: Dr. William Mayo estate, main house with carriage house and greenhouse.

The plans were completed in early 1916, and construction began immediately.[95] The old Head house faced the downtown area, but its successor was oriented to overlook West College Street. The terrain of the block followed a slight upward slope along that street and a level stretch along Monroe Street, around the corner to the north. The lot sloped sharply downward to its northeast corner. Thus, the layout of the estate followed an L shape, with all buildings near the two streets. The rear of the property was a heavily wooded area, with a natural watercourse cutting diagonally across its lower edges. In 1918, four buildings were ready for occupancy. These were the main house, a carriage house and two smaller houses to serve as quarters for the household staff.

Two buildings fronted on West College Street: the main house and the carriage house (Figure 27a). First to be constructed was the carriage house. On the second floor was a caretaker's apartment. The main floor was devoted to the sheltering and maintenance of the family's automobiles. Large doors on the east side opened onto a large paved court, accessible from the main driveway to West College Street. Matching doors on the west side opened onto another, shorter driveway to the side street. The carriage house also contained all of the boilers that provided heat and hot water to the main house. These were fed by pipes running through a tunnel beneath the paved court. The tunnel also provided

pedestrian access to the main house. The carriage house was constructed of the same Kasota stone[96] used in the main house.

A wall of the same stone was constructed on the frontage along West College Street. Two openings, flanked by decorative gateposts, allow access to a horseshoe-shaped driveway. This wall was designed as a formal delineator to the property but is low enough to afford a view of the buildings within by strollers along the street. Rather than presenting a forbidding privacy to the outside world, it has a warm and inviting aspect. Between the wall and the carriage house, on the western end of the property, a greenhouse was erected. This provided Mrs. Mayo with a constant supply of freshly cut flowers, a major part of the ambiance of the main house.

The main house, also built of Kasota limestone, is topped by a roof of greenish slate, quarried near Lake Superior. Three stories tall, over a raised basement, it is fronted by a five-story tower. Its forty-seven rooms occupy a total of twenty-four thousand square feet. The exterior is an amalgam of two styles, the Renaissance Revival favored by Hattie and the Tudor, celebrating Dr. Will's English ancestry. The main entrance to the house is reached via a porte-cochere in the base of the tower. Entry is into a large vestibule facing a wide stairway to the second floor. This is flanked by a formal dining room to the west and Dr. Will's library to the east. A key feature of this floor is a large pipe organ console and keyboard with pipes in the basement below. A semi-octagonal breakfast room is along the rear, its large windows overlooking the gardens below.

The dining room was large enough to accommodate the many guests who constantly arrived in Rochester to visit the Mayos and to observe their clinic facilities. By the time Will and Hattie Mayo moved into the house in 1918, their two daughters were grown. Their original house, farther down West College Street, had been that of a growing family. The new house was intended for formal entertaining, and its design reflected it. The second floor was devoted to bedrooms. The Mayos' master suite was adjoined by a number of comfortable rooms intended for guests.[97] The third floor was a ballroom reached by a flight of stairs.[98] The upper floors of the tower housed Dr. Will's office and a billiard room. The exterior of the tower was in the Jacobean Tudor style, with a flat roof and crenellated parapet surrounding it. The details around the tower windows are repeated in the other windows of the house. The roof of the tower is accessed from within by a folding stairway and was used for Dr. Will's astronomical studies.

The west side of the block, fronting on Monroe Street, was occupied by two small matching houses designed in the Craftsman style (Figure 27b). When the Mayos moved to their new home in 1918, two longtime employees

FIGURE 27B: Dr. William Mayo estate, chauffeur's and steward's houses.

of the Mayo family accompanied them. The chauffeur, Louis West, and his family took up residence in the southern house, conveniently placed near the rear of the carriage house. Mr. West worked as a driver for Dr. W.W. Mayo until his death in 1911 and then joined Dr. Will's household. The steward, Earl Pomeroy, was previously employed by Dr. Charlie as manager of his Mayowood farms and was brought into town to manage Dr. Will's new house. The Pomeroy family occupied the northern house of the pair. The two-story houses are sided in buff-colored stucco and have asphalt shingle roofs sweeping lower in the front, giving them a distinct saltbox shape. The lower façade of each features a full-width porch with arched openings. Above the porches, wide dormers with paired windows overlook the street. The architect's attention to detail still makes these two buildings a key feature of the overall design of the Mayo property.[99]

Will and Hattie Mayo had three children: a son and two daughters. The son died in infancy, but both daughters survived. In 1910, the eldest, Carrie, married Dr. Donald Balfour. The Mayos presented the newlywed couple with a home as a wedding gift. Hattie, the only daughter of jeweler Eleazar Damon, had inherited her childhood home on the northwest corner of Glencoe and Second Streets.[100] Ellerbe & Associates was commissioned to give the old house

a complete remodel, and the Balfours moved in early in 1912. In 1922, when younger daughter Phoebe married Dr. Waltman Walters, Ellerbe & Associates designed a new home as a wedding gift for the couple on the northwest corner of the estate, just north of the Pomeroy house.

In 1938, Dr. William J. Mayo deeded ownership of the estate to the Mayo Foundation. His wish was for the home to be used as a meeting place for men and women of medicine and other humanitarian pursuits to "exchange ideas for the good of mankind." The old greenhouse was razed and replaced with a new house erected on the southwest corner of the estate. The Mayos vacated the main house and moved into this new house in 1939. Dr. Will died later that year. The house became known as the Damon House but more popularly among locals as "Hattie's house." She continued to reside there until her death in 1952. The estate property is still managed by the Mayo Foundation. It remains true to Dr. Will's vision and plays host to many visitors from around the world. It is also an important venue for Mayo events involving Mayo employees and their families.[101]

V.A. KVALE RESIDENCE, 716 WEST COLLEGE STREET

Elizabeth "Jennie" Cook was one of nine daughters[102] of early Rochester builder Horace Cook. The girls were all extremely attractive. In local newspaper accounts of social activities where attendees were listed, they were often just referred to collectively as the "nine beautiful Cook daughters." When Jenny married druggist Victor Kvale in 1895, her father built a house on West College Street as a wedding gift for the couple.

The house (Figure 28) is a slightly modernized version of the popular Queen Anne style. The main block of the house is two stories high with a full attic above. This is dominated by a large tower with arched attic windows, topped with a bell-shaped roof. This roof is repeated atop a gazebo at the east end of the porch. The porch extends across the façade and contains a number of arched details. The arched theme is repeated on the west side of the house, where multiple gables overlook the driveway. The house is sided with a pleasing mixture of clapboards and shingles.

The Kvales occupied the house for a half century. In 1947, it was purchased by Dr. Malcolm Hargraves. In 1950, he commissioned Harold Crawford to remodel the interior and also to modernize the exterior. The arched porch and gazebo disappeared, replaced with a simpler and smaller

Elizabeth "Jennie" Kvale, circa 1894, one of "the beautiful Cook daughters." *History Center of Olmsted County.*

Figure 28: Victor Kvale residence.

entrance porch. Dr. Paul and Susan Ogburn acquired the house in 1987. Using old photos of Horace Cook's original design, they restored it to its original appearance.[103]

J.T. Collin Residence/W. LaPlant Residence, 801 West College Street

The story of the first house at this address is tied to the history of Rochester's neighboring town to the south, Stewartville. Charles Stewart arrived in Olmsted County in 1857. He constructed a mill on the north branch of the Root River, and the town of Stewartville grew up around it. In 1868, a young miller, Job T. Collin, came to work at the mill. He married Charles Stewart's daughter, Helen, in 1872. Charles Stewart died in the mid-1880s, and his son, Charles N. Stewart, took over management of the mill. His sister and her husband moved to Rochester at about the same time. Job Collin entered into the real estate business and became an insurance broker. He also invested in several Rochester mills and played an active role in their management.

In 1886, Job Collin acquired the entire square block on the north side of West College Street between Monroe and State Streets. The land was part of George Head's original holdings and was purchased from John Cook of the First National Bank. That same year, Collin built a home on the east end of the property. Though its address was on West College, it actually faced Monroe Street and overlooked the city below. The house (Figure 29) was large and exhibited many interesting details. The façade was dominated by a large bay, extending to the attic, with angled openings on the first floor. A similar but smaller bay was on the north side. The main entrance was sheltered by a small porch with arches and sawn wood decoration at its gable end. The first floor was faced in red brick, with brick hoods over the windows. The second floor and attic were sided in shingles, with a simple decorative strip at the attic level. Triple windows in the second-floor bays afforded a good view of the city and river below.

Job and Helen Collin moved to a smaller house in 1898. In 1900, he subdivided his block on West College Street into fourteen lots and began selling them. The large house, though now unoccupied, still stood on the two lots fronting Monroe Street. Job Collin died in 1909. When his widow sold both lots in 1910, the old house was razed to make room for two more houses. Helen Stewart Collin died in 1935.

The lot on the southeast corner of the block was purchased in 1910 by William LaPlant. He was a native of New Brunswick, Canada, and came with his family to a farm in Olmsted County in 1861. He left the family farm in 1890 and moved to Rochester. He got his start in business as an agent for the Page Wire Fencing Company. He soon added a travel agency, insurance and building loans to his offerings. A man named Mathew Fitzpatrick was his partner in these enterprises. In 1911, he moved into his new house fronting West College Street. Newly widowed, with a young son,[104] he soon invited his daughter and son-in-law, H.J. Hall, to move in. Mrs. Hall ably served as a mother to her much younger sibling. William LaPlant and the Halls resided in the house until 1929. They then moved to the College Apartments, and the home was purchased by Dr. J.A. Bargen. William LaPlant died in 1938.

The LaPlant house (Figure 30) was a large two-story structure of red brick with Craftsman features. Its hipped roof had wide eaves with simple exposed rafters. This feature was repeated on the wide porch across the entire façade. The porch was supported by large brick pillars with white Doric columns integrated in them. The first-floor façade had wide windows and an entrance with sidelights. The house was razed in the 1960s. It is now a parking lot for the Mayo Foundation House, across the street to the east.

FIGURE 29: Job Collin residence.

FIGURE 30: William LaPlant residence.

ST. MARYS PARK, 901 WEST COLLEGE STREET

In the early 1880s, Rochester first established a centralized water distribution system. A large iron tank was built atop College Hill, on the northwest corner of West College and State Streets. The land was part of a large nursery operated by the Sias family.[105] In 1906, the Mayo brothers purchased the entire block plus additional land to the north. They immediately donated it to the city, and it became Rochester's second park.[106] It extended from West College Street north to where the land dropped steeply down to Zumbro Street. Originally called College Hill Park, it was eventually renamed for the fast-growing hospital just to the west. A long flight of concrete steps[107] led from the northern edge of the park down to Zumbro Street below for the convenience of Pill Hill residents working at St. Marys Hospital. In 1922, the city added the ornate water tower in the park. It is still a landmark. The original iron tank gradually deteriorated and was taken out of service. It was finally removed in the 1990s. St. Marys Park remains a peaceful spot, with its tall trees and green lawns. From its western edge, the view overlooks the sprawling hospital complex below. Though the old steps are no longer in use, a well-worn footpath down to the complex shows that many Pill Hill residents still walk to work.

C.C. WILLSON RESIDENCE, 900 WEST COLLEGE STREET

Charles Cudworth Willson was born in Cattaraugus County, New York, in 1829. He studied the law in Genesee, New York, and was admitted to the bar as an attorney there in 1851. Traveling in search of opportunity, he first arrived in Rochester in 1856. He briefly returned to New York but came back to Rochester and took up permanent residence in 1858. His law practice in Rochester would span sixty-two years. Though he never took on a partner, a number of young men read law in his office and went on to become attorneys with their own practices.[108] Willson also had major farm holdings in Haverhill Township.[109] In 1862, C.C. Willson married Annie Rosenburgh. They would have nine children. After a long marriage, Annie died in 1911.

In about 1860, Willson purchased two square blocks of land[110] from George Head. Near its northern end, he built one of Rochester's finest homes. He named it Red Oaks for the large trees already on the property. The locals,

however, soon dubbed it Willson's Castle, and the nickname stuck. The house was built in two stages. The original two-story house was completed in 1864. A major expansion was completed in 1878 when a new wing was added on the south side, doubling the size of the original house and creating an L-shaped structure. A tall tower was erected at the intersection of the wings. The completed house (Figure 31) occupied the highest point in the city, atop College Hill.[111] The house sat upon a high stone basement, with red brick above. The exterior trim was white. The interior, with its high ceilings and large rooms, provided ample space for the large Willson family. All interior woodwork was of highly prized clear black walnut. The tower soared to a height of seventy-five feet and was surrounded by a porch at its base, with white sawn wood trim. A central staircase wound up through the tower, giving access to all levels. The gable ends of the house each reflected the year they were built. The northern wing of 1864 was fairly austere, with a simple bay and stepped wood trim under the eaves. The other wing, built in 1878, exhibited the more elaborate details of the Victorian era.[112] The roof was steeply pitched with decorative ironwork along its ridges. The chimneys were a rich mixture of fancy brickwork and terra cotta. The tower had tall, hooded windows with a wide cornice under the eaves.[113] The tower roof rose sharply to a small ridge, topped with its own ironwork. The upper room featured windows on all four sides, each enclosed in an ornate dormer.[114]

In 1918, C.C. Willson, then eighty-nine years old and a widower, finally decided to make a change of residence. He moved down the hill to the newly built College Apartments, where he shared lodgings with one of his daughters. The old castle atop the hill remained vacant for just a few months until, one hot summer day, a grass fire was started by a lightning strike just southwest of the house. It quickly spread, and the house was soon aflame. The Rochester Fire Department came clanging up West College Street from the station at its foot, just ten blocks away. The firemen hooked up their hoses to a nearby hydrant and opened the nozzles. To their chagrin, only a small trickle of water came out. The problem soon became apparent. The main city water tank, just across the street, was lower than the burning house. An attempt was then made to connect to the house's own water supply, a large tank in the attic, but that soon crashed through the burning floors to the basement. The frustrated firemen had to stand by and watch the old home reduced to ashes. It was probably no coincidence that a new, higher water tower was erected in St. Marys Park within four years.

C.C. Willson died in 1922. The ruins of his previous home survived him by only a few years. The gutted structure quickly became a favorite

FIGURE 31: Charles Willson residence, also known as "Willson's Castle."

playground for neighborhood children. Concerned for their safety, Willson's heirs had the ruins knocked down, with the rubble pushed into the basement and covered over with soil. By the late 1920s, no trace remained of the once spectacular old mansion that once crowned College Hill.[115] Its departure was emblematic of the transition then underway. The pioneer era of lawyers, bankers and merchants along West College Street was ending. It gave way to a new period of replacement and expansion, typified by the many doctors and other medical professionals occupying the newly named 4th Street SW and the Pill Hill area to the west. And thus we end our virtual stroll up the old street where the ghosts of so many fine buildings still exist but are preserved only in our imaginations.

Appendix I

Builders and Architects of Early Rochester

This book covers more than a half century, from 1855 to 1920. In that period, a number of designers, architects and major builders contributed to the built environment of Rochester. Some were well known, others less so. Their reputations may have been wide or purely local. Their common interest was in producing structures that would both endure and meet the needs of their clients. Unlike some other cities, Rochester's municipal records do not list a builder or designer as part of a property's history. Thus, some excellent work goes unattributed.

The purpose of this appendix is to document briefly some biographical information for these artisans and artists and list some of their known works in Rochester. Not all of them designed houses along old College Street, but many of them did. Where these are cited, only the house number is given. If the known project was a major remodel as opposed to a totally original design, the number is followed by an asterisk.

ARTHUR CLAUSEN, ARCHITECT

Arthur C. Clausen was born in Illinois in 1875. His education is unknown. He was employed as a draftsman in Minneapolis from 1899 to 1909 and then established his own architectural practice. In about 1917, Clausen moved to California. He died in Oregon in 1952. His work in Minnesota

included sanitariums at Chanhassen and Jordan, a number of residences and a planned community for workers at the Pan Automobile Company in St. Cloud. (known projects on West College Street: 720)

HORACE COOK, BUILDER

Horace Cook was born in New York in 1831. He arrived in Rochester in 1855 and began work as a carpenter and builder. He was probably responsible for many of the original business blocks along Broadway. He died in 1896. Major projects included the old Rochester Central School, for which he drew the plans and constructed. He also constructed many early residences. (known projects on West College Street: 716)

HAROLD CRAWFORD, ARCHITECT

Harold Hamilton Crawford was born in southwestern Minnesota in 1888. He completed high school in Rochester in 1908 and received degrees in architecture from the University of Illinois and Harvard University. He returned to Rochester in 1916 and started his architectural practice. He served in the U.S. Army during World War I from 1917 to 1919. He died in 1981. His works included residences as well as public buildings across southern Minnesota. In Rochester, his most iconic work is the Rochester Public Library, completed in 1937. It is now the Mitchell Center, part of the Mayo Medical School. He designed twenty-eight houses in the Pill Hill Historic District and did major remodels for twelve more. (known projects on West College Street: 306*, 512, 619, 716*)

ELLERBE & ASSOCIATES, ARCHITECTS

The firm was founded in 1910 in Minneapolis and is still active today. Its primary focus is on large structures: hospitals, colleges, sports stadiums and commercial buildings. From 1910 to 1915, the firm was known as Ellerbe & Round. In Rochester, its works include clinic and hospital buildings, hotels,

churches, schools and commercial buildings. Only in Rochester did the firm design residences, thirty-three of these in the Pill Hill Historic District alone. (known projects on West College Street: 427, 701, 706, 724, 830, 916)

Franklin Herbert Ellerbe was born in Mississippi in 1870 and came to St. Paul as a young child. After a number of years in the office of the city building inspector, he began an independent architectural practice in 1909. In 1910, he partnered with Olin Round, and during the next five years, their architectural firm became one of the largest in the state. After Round's departure in 1915, Franklin Ellerbe continued the firm under his own name. He died in 1921.

Olin Hart Round was born in Michigan in 1867 and educated at the Chicago Institute of Art. He was employed as a draftsman and architect in St. Paul starting in about 1893. In 1910, he entered into a private practice with Franklin Ellerbe. He left Ellerbe in 1915 and established his own practice in St. Paul. He died in 1927.

Thomas Farr Ellerbe was born in St. Paul in 1892. He attended the University of Minnesota and served in World War II. In 1919, he joined his father's firm. When Franklin Ellerbe died in 1921, Thomas assumed the presidency of Ellerbe & Associates, serving in that capacity until his retirement in 1966. He died in 1987.

G. SCHWARTZ & CO., BUILDERS

The firm of G. Schwartz & Company was founded in Rochester in 1909. Garfield and John Schwartz served as president and vice-president. It soon became the largest construction firm in southern Minnesota. Its primary focus was in Rochester, where it constructed every Mayo Clinic building between 1914 and 1948. It also built a large number of hotels and early hospitals for John Kahler. The firm invested heavily in real estate in the Pill Hill area in about 1910 and built a majority of the homes in the historic district. In 1948, the firm was sold to O.A. Stocke & Company. (known projects on West College Street: 306*, 427, 512, 527, 619, 701, 706, 724, 819, 823, 830*)

Garfield Schwartz was born in LaCrosse, Wisconsin, in 1880. After graduating from high school there, he joined the Noble Construction Company, one of Wisconsin's largest firms. By 1909, he was one of its general contractors. He came that year to Rochester to erect buildings

for the Rochester State Hospital and saw the opportunity to start his own firm. Soon joined by his brother, John, the new construction company made its initial reputation in Rochester with the construction of Mayowood in 1910. Garfield Schwartz retired in 1948. He died in Rochester in 1956.

John Schwartz was born in 1879 in LaCrosse, Wisconsin. After high school, like his brother, he joined the Noble Construction Company. There he learned firsthand the arts of estimating and contract management. These skills would be invaluable when he left in 1910 to join Garfield in Rochester. The brothers worked well together, with Garfield doing field supervision and John running the office. John Schwartz retired to Wisconsin in 1948 and died there in 1956.

HEFFRON & FITZGERALD, BUILDERS

The firm was formed in 1920 and was active until both partners died in 1939. During this period, they built a large number of structures in Rochester and the surrounding area. These included churches, college buildings, residences and commercial structures. In Rochester, these included the Chateau Theater, St. John's Church, the Academy of Lourdes Convent and Heffron High School (named for Heffron's brother, Bishop of the Winona Diocese). The firm also constructed a number of additions to St. Marys Hospital. (known projects on West College Street: none)

Martin F. Heffron was born to Irish immigrant parents in Kalmar Township, near Rochester. He followed his father's trade and entered the construction business. Prior to his partnership with Fitzgerald, he completed a number of projects in Rochester. These included buildings for the Schuster Brewery, as well as the original St. Marys Hospital building in 1889. Martin Heffron was also active in local politics and served as Rochester's mayor in 1906 and 1907. He died in 1939.

William A. Fitzgerald was born in Rochester and graduated from Rochester High School. In 1910, he was employed in the offices of G. Schwartz & Company, where he learned all aspects of the construction business under the tutelage of Garfield and John Schwartz. He left this position in 1920 to partner with Martin Heffron in a new firm. He died in 1939.

Hoffmann & Mosse, Architects

The firm existed only briefly, from 1914 to 1918. It ended with the death of its senior partner, George Hoffmann, in a tragic accident. During its short tenure, the firm designed a number of residences in Rochester. (known projects on West College Street: 823)

George Jacob Hoffmann was born in Germany in 1871. His education is unknown. He immigrated to the United States in 1901 and worked in both Chicago and St. Louis. Hoffmann arrived in Rochester in 1913 and began an architecture practice under the name George Hoffmann & Company, Architects. One year later, he formed Hoffman & Mosse, Architects in partnership with Fred Mosse. George Hoffmann died in 1918.

Frederick H. Mosse was born in Rochester in 1892 and was the son of a local doctor. He graduated from Carleton College at Northfield, Minnesota, in 1914 with a degree in architecture. After his brief partnership with Hoffman, he continued his own architectural practice in the area. He died in 1950.

Horace Horton, Builder and Architect

Horace Horton created much of Rochester's built environment in the late 1800s. He parlayed his early success in local bridge building and design into ownership of the Chicago Bridge & Iron Company, founded by him in 1889. His life and works are fully described in the main text of this book. (known projects on West College Street: 627)

Clarence Johnston, Architect

Clarence Howard Johnston was born in Waseca County, Minnesota, in 1859. He moved to St. Paul as a child and completed high school there. After working in the office of Abraham Radcliffe for a time, he departed to study architecture at Massachusetts Institute of Technology in 1878. Because of financial difficulties, Johnston was forced to drop out after just one year of study. He then spent about two years in the employ of Herter Brothers in New York City. In 1880, he returned to St. Paul and opened his own

office. His firm became one of the most successful in the state of Minnesota. A large number of works, both residential and public, are attributed to Clarence Johnston. He first came to Rochester in 1893 to design a number of buildings for the Rochester State Hospital. He returned in 1919 to design what still today is the heart of the St. Marys Hospital complex, the Surgical Pavilion and other adjoining buildings. He died in 1936. (known projects on West College Street: none)

HARRY JONES, ARCHITECT

Harry Wild Jones was born in Michigan in 1859 and educated at Brown University in Rhode Island and Massachusetts Institute of Technology, where he received a degree in architecture in 1882. He worked for a time for H.H. Richardson in Boston and then for a brief period for a firm in Minneapolis. After a tour of Europe, Jones returned to Minneapolis and established his own practice. From 1885 until his retirement in 1918, Jones's firm produced a number of notable residences and public buildings in the Twin Cities area. In 1914, it designed the First Baptist Church in Rochester, on the corner of Zumbro and Grove Streets (now demolished). Harry Jones died in 1935. (known projects on West College Street: none)

EDWIN LUNDIE, ARCHITECT

Edwin Hugh Lundie was born in Cedar Rapids, Iowa, in 1886. His family later moved to Salem, North Dakota, where he completed high school. In 1904, he came to St. Paul and apprenticed in the office of Cass Gilbert. He later worked as a draftsman for Emmanuel Masqueray. In 1917, Lundie began the solo practice that would last for a half century. His residential designs in the Twin Cities area and along the north shore of Lake Superior are still revered. He did about ten projects in Rochester. Five of these were on Pill Hill, and the rest were in the Mayowood area southwest of the city. Edwin Lundie died in 1972. (known projects on West College Street: 706*, 819)

FREDERICK MANN, ARCHITECT AND EDUCATOR

Dr. Frederick Maynard Mann was born in New York City and moved to Minneapolis as a boy. He received a degree in civil engineering from the University of Minnesota in 1892. In 1894 and 1895, respectively, he received bachelor's and master's degrees in architecture from Massachusetts Institute Technology. He then became an instructor at the University of Pennsylvania, where he received his doctorate in 1901. In 1902, he moved to Washington University in St. Louis, where he founded its architecture school. In 1910, he moved to the University of Illinois and finally, in 1913, to the University of Minnesota to head up its new school of architecture. He served in that capacity until his retirement in 1936. Through his entire career, Mann balanced his academic activities with private architectural practice. By 1916, he was doing projects in Rochester. He designed the medical building that would later become the Worrall Hospital, plus two residential projects in the Pill Hill area. He collaborated regularly with local architect Harold Crawford, who had been one of his students at the University of Illinois. Frederick Mann died in California in 1959. (known projects on West College Street: none)

C.G. MAYBURY & SON, ARCHITECTS

The firm began as a solo practice in Winona, Minnesota, in 1856 and was responsible for the design of a large number of public buildings and residences there over the next half century. It became a father-and-son partnership in 1881. The two homes for the Mayo brothers are its only known work in Rochester. The firm was dissolved in 1904. (known projects on West College Street: 419, 427)

Charles Granderson Maybury was born in Solon, New York, in 1830. He was trained as a draftsman and builder there. In 1856, he moved west to Winona and established himself as one of the earliest practicing architects in Minnesota. He died in Winona in 1917.

Jefferson Nichols Maybury was born in Winona, Minnesota, in 1858. After finishing high school there, he apprenticed for one year with Edward Bassford in Minneapolis. He then returned to Winona and went into partnership with his father. He left Winona for two years in 1903 to work in St. Louis on the Louisiana Purchase Exposition held there. After his return to Winona, and

following his father's retirement in 1904, he moved to Seattle, Washington, where he continued to practice until his death there in 1928.

John M. Miller, Architect

John McGannon Miller was born in Litchfield, Minnesota, in 1890. He was educated at the University of Minnesota and worked as an architect in Jamestown, South Dakota, from 1912 to 1917. In 1917, he enlisted in the United States Army and served in Europe, receiving his discharge in 1919. He then moved to Rochester and established his practice. His specialty became public buildings and especially churches, examples of which still exist across southern Minnesota. In Rochester, he designed St. John's Catholic Church, the central fire station and city hall. He collaborated with Harold Crawford on the initial design of the Rochester Post Office. John Miller did only a few residences, one of which is in the Pill Hill area. He died in 1932. (known projects on West College Street: none)

Purcell & Elmslie, Architects

The firm was established in 1907 in Minneapolis. William Purcell partnered with a college classmate named George Feick, and the business was first called Purcell & Feick. When George Elmslie joined in 1910, it was known as Purcell, Feick & Elmslie. After Feick departed, the firm was known simply as Purcell & Elmslie. Its specialty was residential design, though it did some public buildings. A good example of this is the old city hall in Kasson, just west of Rochester. The partnership was dissolved in 1921. (known projects on West College Street: 306)

William Gray Purcell was born in 1880 and grew up in Oak Park, Illinois. Frank Lloyd Wright was a neighbor and early influence. Purcell was educated at Cornell University and then worked briefly for Louis Sullivan in Chicago. He came to Minneapolis in 1907. He moved to California in 1923 and practiced there until poor health forced his retirement in the early 1930s. He died in California in 1965.

George Grant Elmslie was born in Scotland in 1871 and immigrated with his family to Chicago when he was thirteen years old. He received

his training in architecture by hands-on experience in various offices in Chicago. In 1889, he was hired by Louis Sullivan and would become his chief draftsman. In 1910, he left Sullivan and joined Purcell in Minneapolis. After their partnership was dissolved, Elmslie moved back to Chicago and operated a private practice until the mid-1930s. He died in 1952.

GRANVILLE WOODWORTH, BUILDER

Granville Woodworth was born in Oneida County, New York, in 1832. Trained as a carpenter, he moved west to Janesville, Wisconsin, in 1855. In 1857, he arrived in Rochester, where he soon established himself as a builder. His works in Rochester included the Heany Block, the Cook house, the Ozmun Block, Rommell's Block, Hunter's Block and others. He also constructed the original buildings for the Rochester State Hospital in the 1880s. He died in 1904. In 1929, his daughters donated the funds to construct a large arched gate at Oakwood Cemetery as a memorial to their father. It remains a Rochester landmark today.

Appendix II

Definitions of Architectural Terms

The following definitions cover all of the terms used in this book, plus a few others added for general reference. They are extracted from various architectural dictionaries and other sources.

ART DECO STYLE: A style of architecture from the 1920s and 1930s based on streamlined motifs and related to the early modernistic movement.

ARTS AND CRAFTS MOVEMENT: A late nineteenth-century movement led by William Morris in England in rejection of the cheap, mass-produced items of the Industrial Revolution. Morris stressed the use of handmade furnishings and natural materials in building. Oxford professor John Ruskin's many writings on the subject were widely read and accepted among young architects in both Europe and the United States.

AWNING ROOF: A small, unsupported roof intended to shade or shelter a balcony or window.

BALUSTRADE: A railing or parapet atop a house, balcony or porch.

BAY: A vertical division of a building's interior or exterior, not defined by walls but by fenestration (placement of openings).

BAY WINDOW: An angular or curved projection of a building filled with windows. If curved, it is called a "bow window." If on an upper floor only, it is called an "oriel window."

BEAUX ARTS: A system of architecture applying various classical forms to a modern building, as taught at the École des Beaux Arts in Paris in the late nineteenth century. It became a popular style in the United States, especially in large public and commercial buildings. It also gave rise to some highly elaborate large American houses around the turn of the twentieth century.

BOARD AND BATTEN: (see clapboards)

BOW WINDOW: (see bay window)

BRACKET: A piece of stone or other material intended to support a projecting weight.

CANTILEVER: A horizontal projection supported only by the mass behind it. It is without external bracing and appears to be self-supporting.

CAPITAL: The top portion of a column supporting a horizontal cross member.

CAT-SLIDE: A roof style that sweeps downward, well below the normal window line, sometimes flared slightly at the bottom edge.

CLAPBOARDS: Exterior wooden boards that form a wall. When horizontal, they may be overlapped, beaded or ship-lapped (without a visible lap). Vertical clapboard is also referred to as "board and batten."

COLONIAL REVIVAL STYLE: A collection of traditional European-based building styles, echoing regional historic usage in New England, the mid-Atlantic states and the South. The revival of these styles in American residential design became popular after 1900 and continues in contemporary versions to the present.

COLUMN: A free-standing member with circular cross section. It consists of a base, shaft and capital, which are usually decorated according to established rules.

CORNICE: Exterior trim at the top of a wall where it meets the roof.

CRAFTSMAN STYLE: A product of the Progressive movement in the United States, it first became popular on the West Coast (the "California Bungalow" style) in about 1900 and quickly spread across the country. Popular through the 1920s, the style is most prevalent in smaller residences. It is exemplified by wide eaves, exposed rafter and beam ends, large porches and the use of rustic materials.

CRENELLATION: A notched extension to the top of a wall to give the impression of battlements on a medieval castle.

CUPOLA: A dome on a circular or polygonal base topping a turret or roof.

DENTILS: A series of small square blocks along the lower edge of a cornice.

DORIC: The oldest and simplest of the three orders of classical Greek architecture. It has a heavy, fluted column, no base and a plain capital. When used in residential architecture, the fluting is often omitted.

DORMER: A small gable or shed projecting from a sloped roof and containing one or more windows.

DUTCH COLONIAL REVIVAL STYLE: Evokes a style of house built in the 1700s by Dutch settlers in the Hudson River Valley and across nearby states. It can usually be identified by its characteristic gambrel roof with narrow eaves.

EASTLAKE STYLE: A transition between the Stick and Queen Anne styles, in which the brackets and exterior frame members of the Stick style became more rounded and elaborately detailed. It is based primarily on the work of English architect Charles Locke Eastlake.

EAVES: The under part of a roof overhanging a wall.

ELIZABETHAN TUDOR STYLE: Based on English medieval structures, it is most exemplified by the use of half-timbering and rustic stone on the façade, with steep gabled roofs. It evokes the English countryside and is sometimes also called the Cotswold Cottage style for the region most noted for its original occurrence. This style was revived and became popular across

the United States in the later nineteenth century and was used in many larger houses into the 1930s. The key features are still adapted into some contemporary designs.

FAÇADE: The main exterior wall of a building, normally the front or entry wall.

FOURSQUARE STYLE: One of the six accepted National Styles, it is characterized by a cubical shape with a hipped roof. Popular with early midwestern farmers due to its ease of erection and optimal space, it is usually unadorned without extraneous trim. In urban settings, it was often made more attractive by the addition of roof dormers and wide porches.

GABLE: The triangular upper portion of a wall at the end of a pitched roof.

GAZEBO: A small summerhouse. It can be a separate structure or integrated into a house. When placed on the roof, it is called a "belvedere."

GEORGIAN REVIVAL STYLE: Evokes a pre–Revolutionary War style common in the American colonies, exemplified by its rigid symmetry of plan, central entry and hall, evenly sized and spaced windows and dual symmetrical chimneys. This style was revived and became popular across the United States in the later nineteenth century and was used in many larger houses into the 1930s.

GOTHIC REVIVAL STYLE: A style evoking medieval Gothic residences. Key features are steep roofs with verge boards along the eaves, pointed arches over key openings, leaded glass in windows and vertical board and batten siding.

GREEK REVIVAL STYLE: A popular style in the United States, it was first used in public buildings in the early 1800s. It was based on classical Greek forms such as those of the Parthenon. The decorative aspects of the style were soon used in residences, both large and small, and by 1830, it was widely seen across the country. The key features include classical details such as columns, pilasters and elaborate cornices. These and other decorative details were adopted by local builders through pattern books published during that period.

HALF-TIMBERING: A decorative exterior style of exposed timber framing consisting of boards dividing spaces that are usually stuccoed. It is based on a medieval style of framed construction.

HIPPED ROOF: A roof that slopes equally on all four sides.

HOOD: A projecting molding over an opening to throw off rain.

IONIC: The second of the three orders of classical Greek architecture. It has a graceful, fluted column, a rounded base and a capital with volutes. When used in residential architecture, the fluting is often omitted.

ITALIANATE STYLE: Based on versions of Tuscan villas from the Middle Ages onward. Key features are arched windows with prominent hoods, elaborate porches and low hipped roofs with wide, bracketed eaves. Towers or cupolas are also common.

JACOBEAN TUDOR STYLE: A style based on English buildings from the 1600s, exemplified by stone construction and steep roofs with shaped parapet gables. Some variations also have flat or low hipped roofs with crenellation. Flat-roofed towers with crenellation are also common. This style was revived by American designers about 1890 and used in large houses into the 1920s.

JACOBETHAN TUDOR STYLE: A hybrid style adopted by American designers between 1900 and 1920. It combines the features of the Jacobean and Elizabethan styles and was used primarily in larger houses.

JERKINHEAD ROOF: A variation on the hipped roof, where one slope of the roof is notched to allow for a vertical extension of the side wall.

JULIET BALCONY: A small balcony, usually with a wrought-iron railing. It may be functional with a door to it or purely decorative to highlight a window.

LYCH GATE: A roofed gateway, traditionally used as an entrance to a churchyard. It is sometimes used as an accent in residential designs.

MANSARD ROOF: A two-part roof, with a steeply sloping front and a low hipped roof above. It is named for Francois Mansart, the seventeenth-century French architect who popularized it.

NATIONAL STYLE: A general term referring to the growth of housing across the United States from about 1850 to 1890. It coincided with the growth of

the railroad system, availability of relatively cheap milled lumber and new systems of framing. Built from the pattern books of the day, the result was usually unadorned and functional and followed one of about six somewhat standardized configurations. Many examples exist today, as both city dwellings and farmhouses, especially in the eastern half of the country.

NEW ENGLAND COLONIAL REVIVAL STYLE: A popular revival style in the first half of the twentieth century, it evokes the simple houses built in the northeastern American colonies in the 1600s and 1700s. It is exemplified by a side-gabled roof, with a usually symmetric façade and multi-paned windows. Two of the most common subtypes are the one-and-a-half-story Cape Cod Colonial and the two-story Garrison Colonial with its slightly cantilevered second floor, a vestige of colonial-era blockhouses built for defense. Both of these are still evident today in contemporary adaptations.

ORIEL WINDOW: (see bay window)

PALLADIAN STYLE: Based on the writings of Andrea Palladio in sixteenth-century Italy, this classical style spread across Europe in the 1700s. It emphasized symmetry and strict obedience to rules of order in terms of decoration. Triangular window hoods and tripartite windows are typical features.

PARAPET: That part of a wall that extends above the roof.

PEDIMENT: A triangular, gently sloped gable. It usually consists of a horizontal cornice topped by two sloping cornices and may be found over an entrance or window or in the gable end of a house. When any of the constituent sides contains a gap, the pediment is said to be "broken."

PILASTER: A column or pier from Classical architecture, it is "engaged" (part of a wall), usually with a base and a capital. Originally used as a structural element, its usual function now is mostly decorative.

PILLAR: A free-standing, upright support. Its shape may be round or rectangular.

PORTE-COCHERE: A covered porch large enough for vehicles to drive through.

PORTICO: A formal entry. It may be a porch with pediment and supporting columns or piers or an integral pediment flanked by pilasters surrounding a door.

PRAIRIE STYLE: A progressive style pioneered by a group of midwestern architects in the early 1900s, including Frank Lloyd Wright, William Purcell, George Elmslie, George Washington Maher and others. It was a natural progression from the Shingle-style houses of the late 1800s and incorporated many elements borrowed from the Craftsman style, to which it is related. Both styles were highly popular between 1900 and 1920, but after World War I, tastes changed and reverted to the European-based Revival styles. It is interesting to note that the term "Prairie School" was not coined until the late 1930s, when a writer for a magazine used it in describing the work of Frank Lloyd Wright.

PROGRESSIVISM: A movement in the United States between 1890 and 1920, striving toward a uniquely American style of architecture and interior design. Much of its philosophy and practice was drawn from the writings of John Ruskin and the English Arts and Crafts movement. The Craftsman and Prairie styles of house design both arose from the practitioners of progressive architecture.

QUEEN ANNE STYLE: The quintessential Victorian house style. It is recognizable from its asymmetrical plan, elaborate decoration and wide porches. A key feature was often a conical-roofed tower integrated into the façade. Use of rich colors on the exterior and leaded colored glass in windows are also common.

RAFTER: A sloped beam supporting a pitched roof.

RENAISSANCE REVIVAL STYLE: Based on forms developed during the Italian Renaissance, it was popularized by the Beaux Arts School of Architecture in Paris. American architects studying there in the late 1880s brought the style home with them. Mansions in New York City and Newport, Rhode Island, soon exhibited the style and popularized it across the country by the 1890s. Only large residences typically could take advantage of its key features based on classical forms influenced by the writings of Andrea Palladio.

REVERSE DORMER: A dormer whose front vertical wall meets the rafter line of the roof, giving it a recessed appearance.

RIBBON WINDOWS: Horizontal groupings of multiple windows with a continuous sill and header, it is a trademark of progressive houses built in the early 1900s, especially those of the Prairie style. As a design feature,

it was adopted by modernists in the 1940s and is still a common design element in contemporary buildings.

RICHARDSONIAN STYLE: Also called Romanesque Revival style, it was influenced by early Christian churches across southern Europe. Popularized by Boston architect Henry Hobson Richardson, it was popular in residences built between 1870 and 1900. Its key feature is the heavy arches appearing over windows and entrances. Exteriors were usually of roughly cut ashlar stone, sometimes mixed with brick. Roofs were of slate.

SIDELIGHT WINDOW: A narrow, fixed window placed on one or both sides of an entrance door, sometimes flanked by pilasters.

SOUTHERN COLONIAL REVIVAL STYLE: Evokes the great plantation homes built in the southern United States prior to the Civil War, between 1820 and 1860. In its revival form, it is exemplified by a symmetrical arcade with balanced windows and a center entrance. A key characteristic is a sweeping porch, level with the roof and supported by Classical columns.

STICK STYLE: A transition between Gothic Revival and Queen Anne, this style's key feature is prominent horizontal and vertical exterior framing, which articulates the inner structure of the house.

STUCCO: A durable finish for external walls, applied wet and consisting of cement, sand and lime.

TERRA COTTA: Fired, unglazed clay used for molded ornamentation.

TRANSOM: A horizontal bar placed above a door or window opening with a narrow window placed above it.

TUDOR REVIVAL STYLE: Based on native English building styles of medieval and early Baroque periods, this style was in vogue between 1890 and 1940, particularly for upscale houses. There are two basic subtypes, the Elizabethan and the Jacobean, very different in their key design features. A third subtype, the so-called Jacobethan, is an amalgam of the other two and became very popular in its own right for larger houses between 1900 and 1930.

Usonian: A term coined by Frank Lloyd Wright in the late 1930s to describe his idealized form of low-cost housing for the common man. The first two letters denote the United States since Wright wanted the style to be uniquely American. Houses of this style were typically one story, with wide eaves and low roofs, to be built with low-cost materials and to take advantage of prefabrication techniques wherever possible. Wright and his Taliesen Fellowship designed fewer than one hundred of these homes between 1940 and the early 1950s, the results usually turning out to be beyond the means of the normal middle-class owner. Many of the Usonian concepts were adopted and used more economically by others in the mass-produced housing produced in large suburban subdivisions after World War II.

VERGE BOARDS: Projecting boards placed against a gable, hiding the ends of exposed roof timbers. They are also sometimes referred to as bargeboards.

VICTORIAN STYLE: Actually an entire group of American residential styles popular between 1840 and 1900. Each had its own peak time of popularity, and the features of each were often mixed eclectically in the same structure. The most important styles in this era were the Gothic Revival, Italianate, Queen Anne, Eastlake, Richardsonian, Stick and Second Empire.

WIDOW'S WALK: A flat area at the top of a hipped roof, surrounded by a balustrade and usually accessible from the attic.

WINDOW HOOD: A prominent masonry or wood trim piece above a window, usually arched or triangular in shape.

Appendix III

Rochester Street Names Versus Their Pre-1918 Counterparts

The original street names of Rochester are a diverse mixture, evoking early settlers, geographical features and old stagecoach destinations. While far more interesting than their modern numerical counterparts, they also can be extremely confusing to those wanting to locate a specific property, say, on a pre-1918 abstract or deed. The History Center of Olmsted County has a number of old plat and insurance maps showing the older street names available for viewing at its library.

After the remapping of 1918, only two named streets remained. These were Broadway and Center Street (called Fifth Street before 1918). Currently, Broadway divides the city east and west. Center Street divides it north and south. Streets run east and west and avenues north and south. The strict adherence to the grid system has drifted a bit over the years. The first deviation was when Belmont Hills Subdivision was platted in 1940 and Plummer Circle and Plummer Lane were added to the map. Since then, most new subdivisions and additions use named streets instead of obeying the grid guidelines.

NEW NAME	OLD NAME
East Center Street	East Fifth Street
West Center Street	West Fifth Street

New Name	Old Name
1st Avenue NE	N. Oak Street (also Wabasha Street)
1st Avenue NW	N. Main Street
1st Avenue SE	S. Oak Street (also Henrietta Street)
1st Avenue SW	S. Main Street
1st Place SE	Eagle Street
1st Street NE	E. 6th Street (also Johnson Street)
1st Street NW	W. 6th Street
1st Street SE	E. 4th Street
2nd Avenue NE	N. Liberty Street (also Crescent Street)
2nd Avenue NW	N. Franklin Street
2nd Avenue SE	S. Liberty Street (also Washington Street)
2nd Avenue SW	S. Franklin Street
2nd Street NE	E. Holm Avenue (also Carroll Avenue, also E. 7th Street)
2nd Street NW	W. 7th Street
2nd Street SE	E. Zumbro Street (also Winona Road)
2nd Street SW	Zumbro Street
3rd Avenue NW	N. Prospect Street (also Oronoco Street)
3rd Avenue SE	Dubuque Street
3rd Avenue SW	S. Prospect Street
3rd Place SE	Lillian Avenue
3rd Street NE	E. 8th Street (also Reiss Street, also Hendricks Street)
3rd Street NW	W. 8th Street
3rd Street SE	E. 3rd Street
3rd Street SW	W. 3rd Street
4th Avenue NW	N. Grove Street
4th Avenue SE	Kansas Street
4th Avenue SW	S. Grove Street
4th Place SE	Bennett Place
4th Place SW	Court Street

NEW NAME	OLD NAME
4th Street NE	E. 9th Street
4th Street NW	W. 9th Street
4th Street SE	E. College Street
4th Street SW	W. College Street
5th Avenue NW	N. Hunter Street (also Arvilla Avenue)
5th Avenue SE	Penn Street
5th Avenue SW	Dacotah Street (also S. Hunter Street)
5th Street NE	E. 10th Street
5th Street NW	W. 10th Street (also Silver Creek Road)
5th Street SE	E. 2nd Street
5th Street SW	W. 2nd Street
6th Avenue NW	N. Clark Street
6th Avenue SE	Cherry Street
6th Avenue SW	Glencoe Street (also S. Clark Street)
6th Place SE	Morton Street
6th Street NE	E. Division Street
6th Street NW	W. Division Street (also Horton Street)
6th Street SE	Rochester Street
6th Street SW	W. 1st Street
7th Avenue NE	N. Oakwood Street
7th Avenue NW	N. Grant Street
7th Avenue SE	S. Oakwood Street
7th Avenue SW	Genesee Street (also S. Grant Street)
7th Place SE	Carver Street
7th Street NE	E. Winona Avenue
7th Street NW	W. Winona Avenue
7th Street SE	Lake Street
7th Street SW	High Street
8th Avenue NW	John Street
8th Avenue SE	S. Pearl Street

NEW NAME	OLD NAME
8th Avenue SW	Monroe Street
8th Place NW	Dan Street
8th Place SE	Lowry Avenue (also Durand Street)
8th Street NE	E. Poplar Street
8th Street NW	W. Poplar Street
8th Street SE	Winona Street
8th Street SW	Minnesota Street
9th Avenue NE	N. Beaver Street
9th Avenue NW	Lincoln Avenue (also Horton Street)
9th Avenue SE	S. Beaver Street
9th Avenue SW	State Street
9th Street NE	E. Fremont Street
9th Street NW	W. Fremont Street
9th Street SE	Marion Road
9th Street SW	York Street
10th Avenue NE	Sullivan Avenue
10th Avenue SE	S. Orange Street
10th Avenue SW	Cutler Street
10th Street NE	E. Elm Street
10th Street NW	W. Elm Street
10th Street SE	Joslyn Avenue
10th Street SW	Williams Street
11th Avenue NE	N. Central Street
11th Avenue NW	N. Cascade Road
11th Avenue SE	S. Central Street (also Division Street)
11th Avenue SW	S. Cascade Road
11th Street NE	Eden Avenue
11th Street NW	W. Walnut Street
11th Street SE	E. Walnut Street
11th Street SW	Salem Avenue

NEW NAME	OLD NAME
12th Avenue NE	E. Maple Street
12th Avenue NW	N. St. Marys Road
12th Avenue SE	Payne Avenue
12th Avenue SW	S. St Marys Road
12th Street NE	E. Maple Street
12th Street SW	W. Maple Street
12th Street SE	Cook Avenue
13th Avenue NE	Sullivan Avenue
13th Avenue NW	N. Elliot Road
13th Avenue SE	Sanderson Avenue (also Durand Street)
13th Avenue SW	S. Elliot Road
13th Place NW	W. Chestnut Street
13th Street NE	E. Chestnut Street
13th Street NW	W. Willow Street
13th Street SE	Ireland Avenue
14th Avenue NE	Carlson Avenue
14th Avenue SE	Carlson Avenue
14th Avenue SW	Flathers Avenue
14th Street NE	Wabasha Road
14th Street SE	Harriett Avenue
15th Avenue NE	Madsen Avenue
15th Avenue SE	Durand Street
15th Avenue SW	Fanning Avenue
15th Street NE	Water Street
16th Avenue NW	N. Kutzky Road
16th Avenue SW	S. Kutzky Road
16th Street NE	Elder Street

Notes

PREFACE

1. For a biography of Harold Crawford and a catalogue of his many architectural projects, refer to the book *Houses on the Hill, The Life and Architecture of Harold Crawford*. (See bibliography for details.)
2. During Harvey Ellis's career, architectural journals such as *Western Architect* and *Pencil Points* published renderings of current buildings in process. Many of these were by Ellis, and through them, his name and skill became widely known by his peers.
3. Harvey Ellis's works during his travels were mostly unsigned, bearing instead the name of the hiring architect. Thus, much of his work was mostly unrecognized until Professor Eileen Michels published a half-century of research in 2004 in her book *Reconfiguring Harvey Ellis*. (See bibliography for details.)
4. The author wishes to forestall the usual question: "So, did you do all those drawings on the computer?" The answer is, emphatically, no! The two maps accompanying the text were done on a computer, using AutoCAD, but all of the other renderings in this book were done in pen-and-ink, using those old "dinosaur drafting" techniques that have not even been taught in trade schools for a number of years. Sometime in the past couple of decades, this type of drawing has evolved from a trade to an art form in the perception of the consumer. Even though the author now shows his renderings in an art gallery, he refuses to label himself as an "artist" and instead proudly proclaims himself a "draftsman" in the gallery biographies. People buying the work don't seem to care, but the author does.

5. Also included are a few architecturally interesting buildings that were erected on the site after another building was lost. These, too, have fallen, and I decided to include them in this tribute.

Part I

6. In 1851, the Treaty of Traverse de Sioux forced the Dakota off their wide territories in southern Minnesota and onto a narrow strip of reservation land along the Minnesota River. Speculators and settlers from the East flooded into the region to take up the newly available land. This overcrowding of the native people, plus a long series of broken promises, led to a great uprising on the Minnesota frontier in 1862.

7. The laws basically allowed an individual to stake a claim on a quarter section of land (160 acres) and purchase it from the government for a fixed price of $1.25 an acre. The claimant was required to build a structure on the land prior to making the purchase from the government. These laws presaged the Homestead Act of 1862, which made the land free to the claimant after five years providing that he built on the land and lived on it.

8. The river was originally called Wasionja by the Dakota. Early French trappers experienced problems ascending the river from its mouth on the Mississippi due to the current and the many fallen trees washed from its soft banks. They named it the Riviere de Embaras, meaning "the river of difficulties." On the earliest maps of the area, done by army surveyors, this was anglicized to the "Embarrass River." The name "Zumbro" was a corruption of the French pronunciation of the original name. As early as 1838, Henry Sibley referred to it as the Zumbro in his diary, and that may account for the spelling finally adopted.

9. Shortly thereafter, the Territorial Courts awarded a cash judgment to the original claimants, which George Head paid with funds provided by his brother-in-law, Morris Cutler of Waukesha, Wisconsin. This modus operandi served Head well over the next few years. Financed by Cutler and partnering with early Rochester attorney Eleazar McMahon, Head would repeat this process a number of times on other prime quarter sections. In each case, original claimants received cash and Head got the land.

10. A multi-paneled mural commemorating this event was painted in the 1930s by artist David Granahan for the new Rochester Post Office. When the building was razed, the mural was given to the History Center of Olmsted County and is now prominently displayed in its museum.

11. Searches of Olmsted County and Rochester city records yield nothing regarding any of the early claimants. The Minnesota Historical Society's records of early claims contain nothing on Rochester. Perhaps the original College Hill claim slumbers somewhere in a federal archive, but the claimant's name remains a mystery.

12. The steep hillside today overlooks 2nd Street SW.

13. This led through the current site of St. Marys Hospital.

14. Today this is 10th Avenue SW.

15. Huidekoper was a Unitarian minister and the founder of the Meadville Theological School, where he also taught for many years. Descended from early settlers, he was the wealthiest individual in the area. He was a benefactor of the seminary and also of the city of Meadville, Pennsylvania. He died in 1892.

16. One clause of the law specified that a claimant was limited to one quarter section. However, this clause was generally overlooked, and the courts allowed Head's claim and merely levied a cash penalty.

17. In an address to the Rochester Men's Club in 1910, Willson reminisced about early lawyers in Rochester. The majority of his talk focused on McMahon, who was a most colorful character. Willson described him as "a most excellent attorney, when sober."

18. Today this is 3rd Avenue SE. In 1856, it was the stagecoach route out of Rochester to Dubuque, Iowa.

19. George's mother, Alice, did not accompany the party. An invalid, she moved in with her daughter and son-in-law in Waukesha. She died a few years later and is buried in the Cutler family plot there.

20. Letter from J.F. Van Dooser to Mrs. John Rowley, dated June 28, 1906, History Center of Olmsted County archives.

21. Before the coming of the railroad in 1864, stagecoaches ruled the transportation system in southern Minnesota. As a busy hub, Rochester soon saw other hotels and inns spring up. The stagecoach line operators built a large livery operation along East College Street. It was located near the current Riverside School.

22. Called Strawberry Dam, it was located near the current site of the Silver Lake Fire Station. It vanished in the 1930s when a new dam on North Broadway was built and Silver Lake was formed.

23. The North Rochester Power Company raised the funds to build the dam, excavate the millrace and line it with rough masonry. It then managed the water rights and collected rents from the mill owners.

24. Mills blossomed along the millrace, as well as on nearby Bear Creek and Cascade Creek, in the late 1800s. They came and went, making flour and

woolen goods, plus sawing lumber. Most were rickety structures of wood and succumbed to fire at one time or another. The exception was the Olds & Fishback Mill, which straddled the millrace in 1857. Constructed of stone, the large building survived long after it ceased operation in the 1920s and was finally razed in 1953. By the 1920s, any remaining mills had long ago converted from water power to more efficient steam. The old millrace was roofed and covered over. Vestiges of the race still remain beneath downtown Rochester. In 1957, workers replacing the 4th Street SE bridge broke into it and had to do a large backfill before continuing. Even today, workers on the lower level of the Riverside Building mention hearing water flowing beneath them on days when the river is high.

25. The two main competitors were the budding towns of Oronoco and Marion. The campaign was rancorous and the referendum fraught with chicanery on all sides.

26. The *Rochester Post* of May 28, 1870, reported Head's liabilities as amounting to $52,436.99.

27. During his time in Fergus Falls, Head borrowed a total of $2,000 from Cutler and apparently repaid it with interest. However, he had used Cutler's name on his initial claims for six different tracts of land. For the remainder of his time in Fergus Falls, he continued to do all his business in Cutler's name, though he had no direct interest in Head's further dealings. One can only assume that Head remembered his bankruptcy experience in Rochester and was trying to shelter his holdings against some unforeseen financial problems.

28. By this time, George Head's sister, Mrs. Morris Cutler, had died, and Morris was himself in failing health. He had turned over his own extensive holdings to a younger brother and his wife. It was the younger Cutlers who made the move against the Head estate, based on Morris's name appearing on various deeds in Fergus Falls. They offered Sophia Head only the house she was living in plus about $5,000 in cash. Jonathon Head, George's brother in South Dakota, was outraged by this treatment of his sister-in-law and filed a countersuit in her name.

29. At the time of the lawsuit, newspapers in St. Paul, Rochester and Fergus Falls reported George Head's estate to be in excess of $200,000.

30. Frank B. Kellogg read for the law and passed the bar in Rochester, serving as city and county attorney in addition to a successful private practice. By the time of the Cutler lawsuit, he was practicing in St. Paul but willingly represented the Head family, old friends from his youth. He would eventually serve in the United States Senate and as ambassador to

England. He was secretary of state in the Coolidge administration. Frank B. Kellogg received the Nobel Peace Prize in 1929 and died in St. Paul in 1937. Rochester's Kellogg Middle School is named for him.

31. A Sanborn Insurance map of 1914 shows the house's footprint, labeled as "ruins." Scavenged for its brick and other fittings, fragments of this historic house probably still exist in many other structures in Rochester.

32. Located on the current site of the Mayo Clinic's Siebens Building.

33. The Mayo farm was on the site of the current Homestead Addition. The land was purchased in 1870 from Jonathon Head, George's brother.

34. For a full and objective history of the Mayos and the early Mayo Clinic, the best reference is still Helen Clapesattle's 1940 book *The Doctors Mayo*. (See bibliography for details.)

35. For a history of Ellerbe & Associates, refer to the book *A Century of Elegance: Ellerbe Residential Design in Rochester, Minnesota*. (See bibliography for details.)

36. Dr. Henry Plummer's estate occupied the summit of Quarry Hill just to the south of Pill Hill. After his death, all but eight acres of the land were sold for development. This became the Plummer Circle neighborhood, with homes dating from about 1940 to the mid-1950s. The remaining land and estate buildings are now a city park.

37. This was on land originally part of Mayowood farms. Donated by Dr. Charles H. Mayo for the Mayo Institute of Experimental Medicine in 1920, a portion of the land was eventually opened for residential development in 1950.

38. The original nomination package, prepared by the Minnesota Historical Society in 1989, is in the archives of the History Center of Olmsted County. It contains descriptions of all the structures and the rationale for their inclusion.

PART II

39. Robert McReady and his brother, Silas, arrived in the Rochester area in 1854, at about the same time as George Head. Silas McReady served as Rochester's first deputy sheriff and became a well-known local character. As bailiff for the court, he would supposedly recite in one breath, "Do you swear to tell the whole truth, nothing but the truth, so help you God? You owe me a quarter." The McReady brothers left the area in 1867.

40. In addition to the sheriff, this provisional group included three commissioners, a registrar of deeds, a treasurer and a judge. The first general elections were held in the county on October 9, 1855.

41. Thanks to an 1883 history of Olmsted County, the names of the ten "regulators" who enforced the law in Rochester during the first year of its existence are recorded. They were Thomas Cummings, Grant Cummings, L.W. Bucklin, J.A. Bucklin, James Levering, G. Goodwin, A. Goodwin, William Eaton, Charles Martin and S.S. Goodrich.
42. The approximate route can be deduced by following U.S. Highway 52 on a modern road map.
43. Early photographs show that the balconies were favorite vantage points for local dignitaries and their guests. The building became the town center for political rallies, parades and other events.
44. The clock was paid for through a drive for public donations, led by Mr. C.A. Jocelyn. By 1898, sufficient money had been raised, and the clock was installed. This clock is all that remains of the old firehouse. Today, it occupies a glass enclosure in front of the Mayo Civic Center.
45. A local architect, George Hoffmann, was serving as volunteer traffic warden, trying to control the speeding vehicles. A truck full of celebrating workers from Mayowood Farms struck him and killed him instantly.
46. The building was the first major project of the Rochester Women's Club, founded in 1894. The club raised funds from the community to support this and other worthy endeavors. The descendant of this group is today's Civic League of Rochester.
47. With the opening of this bridge, U.S. Highway 63 was able to pass directly through the city on Broadway. Today, four lanes wide, it carries a heavy load of automobile and truck traffic.
48. *Rochester City News*, November 16, 1859.
49. This was George Head's father-in-law, Rasmus Neilson. He and his wife moved to Rochester in 1856. He eventually assumed the management of the store.
50. The *Rochester Record & Union* of March 30, 1883, reports one such visit by Head, who installed a new plate-glass front on the building and made other improvements.
51. In 1916, Harold Crawford completed his studies at Harvard and returned to Rochester to begin his practice. Dr. Frederick Mann founded the School of Architecture at the University of Minnesota in 1913. Prior to that, he was at the University of Illinois, where he was Crawford's undergraduate faculty advisor and mentor. To help his young friend establish himself, Mann collaborated with him on a number of projects in 1916, lending his recognizable name. The drawings of the Tollefson & Vine remodel in the archives of the History Center of Olmsted County are all done by Harold Crawford.

52. Even though this building still exists, the author has chosen to include it here because it is the only remaining nineteenth-century commercial building remaining along 4th Street SW.

53. The other two were the Cascade Brewery and the City Brewery.

54. The entrance was near the current intersection of 1st Avenue SW and 5th Street SW.

55. It was located in the middle of the 300 block of South Broadway, on the west side.

56. Dr. Allen's understanding of how such diseases were passed on was unusual for country doctors of the day. When treating patients for a communicable disease, he would first quarantine the house. He then did all communication with the patient's family and dispensed medicines through an open window. In this way, he did not spread the disease further to other patients. He had a great recovery rate and soon became popular, especially in the rural areas.

57. When Dr. Mayo and his sons formed a partnership with other local doctors, Dr. Allen was invited to join. He opted to maintain his independent practice.

58. The house at 725 3rd Avenue SE was along the old stagecoach road to Dubuque. Dr. Allen remodeled the property into a nursing home and named it the Eastside Hospital. In later years, Dr. Allen and his wife would return there and take up permanent residence.

59. The footprint of this house appears on an 1878 plat map. It was rectangular, with a small wing on its south side. The house faced Prospect Street, now 3rd Avenue SW.

60. Note the similarities of this house to the nearby homes of W.D. Hurlbut and C.H. Chadbourne, both of which predate the Clarks' remodel by a number of years. By the 1880s, the Italianate style was becoming somewhat passé but would have still appealed to conservative homeowners.

61. When J.D. Blake moved away, he sold his house to his sister and her husband, Eliot Knowlton. This was on West Center Street, where Methodist Hospital is today. In 1909, they sold that house to John Kahler, who made additions to it and operated it as the Kahler Hotel. When a new Kahler Hotel was built in the 1920s, the old building was renamed the Damon Hotel and continued operations.

62. The building still stands, though heavily remodeled, on Rochester's busiest commercial corner. It was occupied by Dayton's for a number of years and then by Red Lobster. It now houses Mayo Clinic offices.

63. In 1907, William Purcell and George Feick, a friend from his college days at Cornell, formed an architectural firm in Minneapolis. Purcell had

grown up in Oak Park, Illinois, and was a neighbor of Frank Lloyd Wright. As a young architect, he was heavily influenced by Wright and also by Louis Sullivan. George Elmslie, a longtime associate of Sullivan, moved to Minneapolis and joined the partnership in 1910. Elmslie's résumé included a number of collaborations with Sullivan, notably the National Farmer's Bank in Owatonna, Minnesota, completed in 1907 and now a National Historical Landmark. The partnership lasted until 1921.

64. Purcell & Elmslie did a number of projects in small towns across southern Minnesota but never could get a foothold in Rochester. This could have been due to the local dominance of Ellerbe & Associates. In addition to the Knowlton house, Purcell & Elmslie did two other design proposals in Rochester, one for hotel operator John Kahler in 1908 and the other in 1911 for Dr. W.F. Braasch. Both commissions were lost to Ellerbe. It was probably his desire to obtain further commissions in Rochester that prompted Purcell to put up with Knowlton's sometimes thorny approach and complete the plans.

65. Marion Alice Parker was a graduate of the University of Minnesota and the first female architect to be licensed in the state. She worked for Purcell & Elmslie between 1910 and 1916. She then opened her own independent practice and produced a number of commissions in the Twin Cites. In the 1920s, she retired to California and died there in 1935.

66. William Purcell retired to Pasadena, California, in the 1930s due to poor health. He then began to dictate a memoir of the Minneapolis firm, called "The Parabiographies." It is organized by year and is a pastiche of Purcell's memories. In the 1910 volume, he devotes an entire section to his experiences with E.A. Knowlton. The title, "The Client from Hell," pretty much sums up the relationship. The document is on file in the Northwest Architectural Archives at the University of Minnesota.

67. The effort was spearheaded by Donna Melin, who wanted to save the house due to its connection to Purcell & Elmslie. Her plan was to have the house moved to a different site and preserved, but the necessary financing was not achieved. Her crusade received local media attention not only in Rochester but also in the Twin Cities. (See *Rochester Post Bulletin* of May 7, 1978, and *St. Paul Pioneer Press* of July 23, 1978.)

68. On the second day of the battle, as a Confederate attack was about to turn the Union lines, General Winfield Scott Hancock made a fateful decision. He ordered the First Minnesota to move forward and stop them. After a short and bloody encounter, the Minnesota troops prevailed but suffered incredible losses.

69. The mill received flax from area farms and spun it into linen thread. The operation was enabled by a recently patented process that could handle the long fibers of the flax. Henry Richardson was one of the first to obtain the necessary machinery and put it to work. Farmers in the area leapt at the opportunity, and flax became a highly profitable crop for a number of years.

70. In Rochester city directories of the early 1900s, most residents of West College Street proudly listed their occupations and positions with their individual entries. With all his many business and political interests, Henry Richardson showed considerable flair by listing his occupation simply as "gentleman."

71. The Italian Villa style was popularized by the pattern books of architect Andrew Jackson Downing in the late 1840s. His designs usually featured an elaborate tower or cupola. When omitted, the result is sometimes called the American Bracketed style. The Chadbourne, Clark and Hurlbut/Kahler houses described in this book are all of this subtype. For a good example of true Italianate Villa style, visit the Huff House in Winona, Minnesota.

72. He was a partner in the Weber & Heintz Pharmacy, today known as Weber & Judd Drugs.

73. The new owner painted out "Hall" in the sign and replaced it with "Guesthouse," making it read "Edith Mayo Guesthouse." The clinic naturally objected vehemently to this hijacking of the Mayo name. The thrifty owner responded by merely painting out an "o," and the old building spent the remainder of its existence as the "Edith May Guesthouse."

74. A group of local preservationists had earlier managed to get the house placed on the National Register of Historic Places. They cried foul when the owner had the building demolished without notice, and a minor commotion ensued. Finally, the property owner was brought into court and charged only with not having the proper permits for demolition and paid a small fine as a result.

75. She was the daughter of Eleazar Damon, a local jeweler.

76. The city of Rochester had introduced a centralized water distribution system only a few years before. The first reservoir was a large iron tank atop College Hill, then the highest point in the city. The mains were run downhill beneath West College Street to serve the homeowners below.

77. The floor consisted of four large panels, which could be laid flat and connected on the lawn. When not in use, the floor would be stored away in the carriage house at the rear of the property.

78. While a director of Oakwood, Furlow was instrumental in acquiring the land along the river, which doubled the size of the cemetery. Impressed with the beauty of the addition, he promptly bought the plot where he and his wife rest today, near the banks of the Zumbro.

79. In his later years, Kahler was fond of recalling this return. Finding himself broke and unable to find work in Buenos Aires, he sold all of his belonging (including his pistol) to purchase a ticket on a steamship to Florida. He managed only to keep his favorite possession, a tall silk top hat. He finally arrived in Northfield, dusty and penniless but still wearing his elegant hat.

80. Only one of the three original Colonial Hospital buildings still exists. It is now shadowed by the neighboring Methodist hospital, which looms over it.

81. In addition to its long association with the Mayo Clinic, the firm also had a similar relationship with the Kahler Corporation. It designed a number of downtown hotels and retail spaces for Kahler.

82. Dr. Hench was a prominent Mayo Clinic physician and researcher. In 1951, he shared the Nobel Prize in Medicine with his Mayo colleague Dr. Edward C. Kendall. The prize was awarded for their discovery of the drug cortisone.

83. On the former site of the house, a tiny bit of it survives. A fragment of stone wall and some slate steps are almost concealed amidst some landscaping in the middle of the parking lot. It is maintained by the city and is Rochester's smallest city park.

84. The demolition of old pioneer residences often triggered protests by local preservation groups, as did this one. This time, however, the effort was better organized than usual. The Heritage Group, led by Louise Hill, was formed to preserve the city's early character. On the morning this old house was to be razed, a group of eager volunteers swarmed over the structure and removed many of its ornaments and even some of the sash. Some of this material found its way into the old Whiting House, which had been recently moved to Central Park by the Heritage Group.

85. Stories of A.C. Gooding's civic activities and his generosity still abound in Rochester. Of all the many homeowners mentioned in this book, he was the only one whom the author met in person. In the late 1960s, I was part of a fraternal group that called on him to deliver a gift basket of fruit at Christmas. We were welcomed and entertained by a very spry man of slight build, as I remember. He was of an extremely keen mind and exhibited a genuine interest in getting to know all of his guests. A few

months later, he attended a meeting of the same organization and, to my surprise, recognized all of us and called us by name.

86. The only survivor of these is a Pratt truss bridge over the Zumbro River in Oronoco Township at "Frank's Ford." Built in 1895, it still stands in its original location but is no longer open to vehicle traffic. A scale model of this bridge is on display in the museum of the History Center of Olmsted County.

87. *Rochester Post*, June 20, 1868.

88. Of all the buildings reconstructed in this book, the appearance of George Head's house was the most difficult to derive. Its location and footprint are firmly established by two independent sources, but the style and layout are unknown. The only photo to come to light is a long shot of the hill taken in the 1860s. The Head house appears in the distance, a white two-story, but so distant as to make details impossible to see. The author has been forced to resort to inference based on knowledge of Head's personality and background. I have chosen the Greek Revival style for the house because that was the norm for more substantial homes back in Watertown and Waukesha. It was by the 1850s an established and conservative style, not flashy or fashionable, as the other more recent villa-based styles popularized by Andrew Jackson Downing and others. I chose the Greek Revival to reflect George Head's obvious desire to be recognized as a serious pillar of the community that he helped to found.

89. In 1870, Jonathon Head sold eighty acres of his land to Dr. William Worrall Mayo, who established a farm, known to all as the Mayo Homestead. In the late 1940s, the Mayo Foundation built Homestead Addition on the farmland. The original Mayo farmhouse was on the site of today's Homestead United Methodist Church.

90. Nancy Head Baker served as postmistress of Rochester for a period of time. She and her husband had six children. When Jonathon Head sold his Rochester holdings in 1870 and moved to Mitchell, South Dakota, the Bakers accompanied him and resettled there.

91. The abandoned house was a magnet for scavengers. Its bricks and timbers were salvaged for use elsewhere. Its windows, doors and interior woodwork found new homes in other structures around the town. Some of these materials probably still exist in Rochester buildings as unknown memorials to Rochester's founder and his fine house on the hill.

92. Interest in astronomy among the children of Dr. William Worrall Mayo stemmed from their mother, Louise. When W.W. Mayo established his farm near Rochester, a prominent tower was erected on the house for

Louise's telescope. Dr. Charlie's new home at Mayowood included a rooftop observatory as well.

93. Niles Academy was a private high school that emphasized the sciences as well as the classics. Dr. W.W. Mayo felt that its curriculum fit the needs of future physicians better than the courses offered at Rochester's Central School and enrolled his sons at Niles Academy. Other local parents followed his lead, among them Eleazar Damon, Hattie's father. The school occupied the upper floor of the Heaney Block, located on the northwest corner of Broadway and 2nd Street SW.

94. The plans done by Ellerbe & Associates for the William J. Mayo house are in the Northwest Architectural Archives at the University of Minnesota. They include a number of sketches, perhaps done by Hattie Mayo. Because they are unsigned, it is impossible to establish their provenance. A set of later floor plan sketches for the house built for Carrie Mayo and her new husband, Waltman Walters, on the estate in 1922 are a different matter, however. They currently reside in the Mayo Clinic archives, accompanied by a note from Mrs. Walters stating that they were done by her mother. Hattie's influence is further demonstrated by the final floor plans done by Ellerbe & Associates for the Walters house. They exactly match Hattie's preliminary sketches.

95. The builder was Garfield Schwartz. A key Rochester builder from 1910 until his retirement in 1948, his firm constructed every Mayo Clinic building, hotels for John Kahler and a large number of residences on Pill Hill. For more information on his life and work, refer to this author's *A Century of Elegance: Ellerbe Residential Design in Rochester, Minnesota.* (See bibliography for details.)

96. The stone used was quarried near Mankato, Minnesota.

97. Many important people stayed with the Mayos over the years. Helen Keller was one, and Eleanor Roosevelt occupied one front bedroom enough times that it is still currently associated with her name.

98. In 1939, when the Mayo Foundation took over the house, the third-floor ballroom underwent a major renovation by Ellerbe & Associates. It was later named Balfour Hall in honor of Dr. Donald Balfour, Dr. Will's son-in-law and chairman of the Mayo Foundation.

99. Over the years, an urban legend spread that these two small houses were ordered from Sears & Roebuck as precut kits and erected on the property. There is no basis for this. The plans for these houses were done by Ellerbe & Associates and are in the Northwest Architectural Archives as part of the original plan set for the Mayo Estate, done in 1916.

100. The current address is 627 6th Avenue SW. Today, it is the Civic League day-care facility.

101. The Mayo Foundation House exists today and is the architectural focus of 4th Street SW. Because of its historic importance, it is one of three extant properties described in this book.

102. Horace Cook had no sons, but his daughters all married well. A list of their married names is a veritable who's who of second-generation pioneer business and professional families in Rochester.

103. The Kvale house is one of the few nineteenth-century structures remaining on 4th Street SW and certainly the only one with its original appearance. The author could have used a photo but did not, mostly for the sheer joy of drawing it instead.

104. The son, William LaPlante (the "e" added by him as a young man), attended law school and eventually became a city judge. He served Rochester in this capacity for many years.

105. The nursery was started in 1857. It occupied the land north of today's 10th Avenue SW, now part of St. Marys Hospital. The original 1857 Sias farmhouse survives at 715 10th Avenue SW. The large garage building behind 723 10th Avenue SW is the barn and nursery headquarters built the same year.

106. The first was Central Park, on the northern edge of downtown and part of the original plat of the city.

107. A small portion of these steps still exists at the edge of the park overlooking 2nd Street SW. They are heavily fenced to prevent access.

108. Two of these were particularly notable. Frank B. Kellogg became a United States senator and secretary of state. He received the Nobel Peace Prize in 1929. Burt W. Eaton became the first general counsel for the newly formed Mayo Clinic and served in that capacity for many years. Active in local affairs, he also founded the Olmsted County Historical Society.

109. With over eight hundred acres in wheat plus major livestock operations, his holdings included the current site of Rochester Community & Technical College. In the late 1800s, Rochester State Hospital was also erected on a portion of Willson's farmland.

110. The property extended from today's 4th Street SW west to 6th Street SW, bounded on the east and west by 9th and 10th Avenues SW. Even though the original plat of 1856 shows a street bisecting the property, it was never realized, and today's 5th Street SW dead-ends at 9th Avenue SW.

111. This distinction lasted until Northern Heights Subdivision was annexed by the city in the 1960s. Its highest point tops College Hill's summit by just a few feet.

112. According to local newspaper articles of 1878, the addition was designed by an architect from Chicago. Unfortunately, his name is not mentioned in any of these stories, and none of the plans drawn by him have come to light. But this still makes Red Oaks one of the first architect-designed residences in Rochester.

113. The current owner of the property recently unearthed two pieces of the original cornice. Heavy blocks of terra cotta, with molded foliage designs, they show the level of detail lavished on the house when it was built.

114. Local legend states that C.C. Willson was fond of climbing to the top floor of the tower and looking at his farm property to the east through a large telescope. Woe be unto any hired hand not performing his duties to Willson's satisfaction.

115. Willson's Castle was resurrected briefly a few years ago. The current owner of the property and the author staked out the footprint of the old house and delineated its outline with brightly colored rope. During a weeklong series of walking tours, the author was able to show the house and describe it on its original site. The enthusiasm shown by the tour participants made it well worth the effort.

Bibliography

Allsen, Ken. *A Century of Elegance: Ellerbe Residential Design in Rochester, Minnesota.* Minneapolis: Ellerbe Becket, 2009.

———. *Houses on the Hill: The Life and Architecture of Harold Crawford.* Kenyon, MN: Noah Publishing, 2003.

———. "Whatever Happened to Good Old George? The Rise and Fall of the 'Father of Rochester.'" *Olmsted Historian* 32, no. 1 (Spring 2012).

Calavano, Alan. *Rochester: Postcard History Series.* Chicago: Arcadia Publishing Company, 2008

Clapesattle, Helen. *The Doctors Mayo.* Minneapolis: University of Minnesota Press, 1941.

Fleming, John, Hugh Honour and Nicholas Pevsner. *The Penguin Dictionary of Architecture.* 4th ed. London: Penguin Group, 1991.

Foster, Gerald. *American Houses: A Field Guide to the Architecture of the Home.* New York: Houghton Mifflin Co., 2004.

Larson, Paul Clifford. *Minnesota Architect: The Life and Work of Clarence H. Johnston.* Afton, MN: Afton Historical Society Press, 1996.

Lathrop, Alan. *Minnesota Architects: A Biographical Dictionary*. Minneapolis: University of Minnesota Press, 2010.

Mayo Foundation House. Mayo Clinic Publication No. MC1580-02. Rochester, MN, 2010.

McAlester, Virginia, and Lee McAlester. *A Field Guide to American Houses*. New York: Alfred E. Knopf, 1984.

Michels, Eileen Manning. *Reconfiguring Harvey Ellis*. Edina, MN: Beaver's Pond Press, 2004.

Mulfinger, Dale. *The Architecture of Edwin Lundie*. St. Paul: Minnesota Historical Society Press, 1995.

Scott, Benjamin I. *Frontier Chapel to Spiritual Oasis: 150 Years of Calvary Episcopal Church*. Rochester, MN: Calvary Episcopal Church, 2010.

Severson, Harold. *Rochester: Mecca for Millions*. Rochester, MN: Marquette Bank, 1979.

St. Mane, Ted. *Images of America: Rochester, Minnesota*. Chicago: Arcadia Publishing, 2003.

Vandam, Elizabeth A. *Harry Wild Jones: American Architect*. Minneapolis: Nodin Press, 2008.

Index

About the Author

K en Allsen has had a lifelong interest in architecture and old buildings. He was trained as a draftsman in the 1950s, and technical drawing has been either his vocation or avocation since then. During a long career as a software developer, he managed to continue drafting as a sideline and designed a number of residences in the Rochester, Minnesota area. In 1995, with his retirement from IBM, he started a full-time drafting and design service. But he soon discovered that it was far more enjoyable to study, write and talk about buildings than to design them.

Photo by Teresa DeLuca.

With three books now in print, Ken has become a full-time freelance architectural historian. His mission is to preserve the architectural history of his corner of the world, southeastern Minnesota. He lives in Rochester with his wife, Nancy.